DATE DUE

RENOIR
and his art

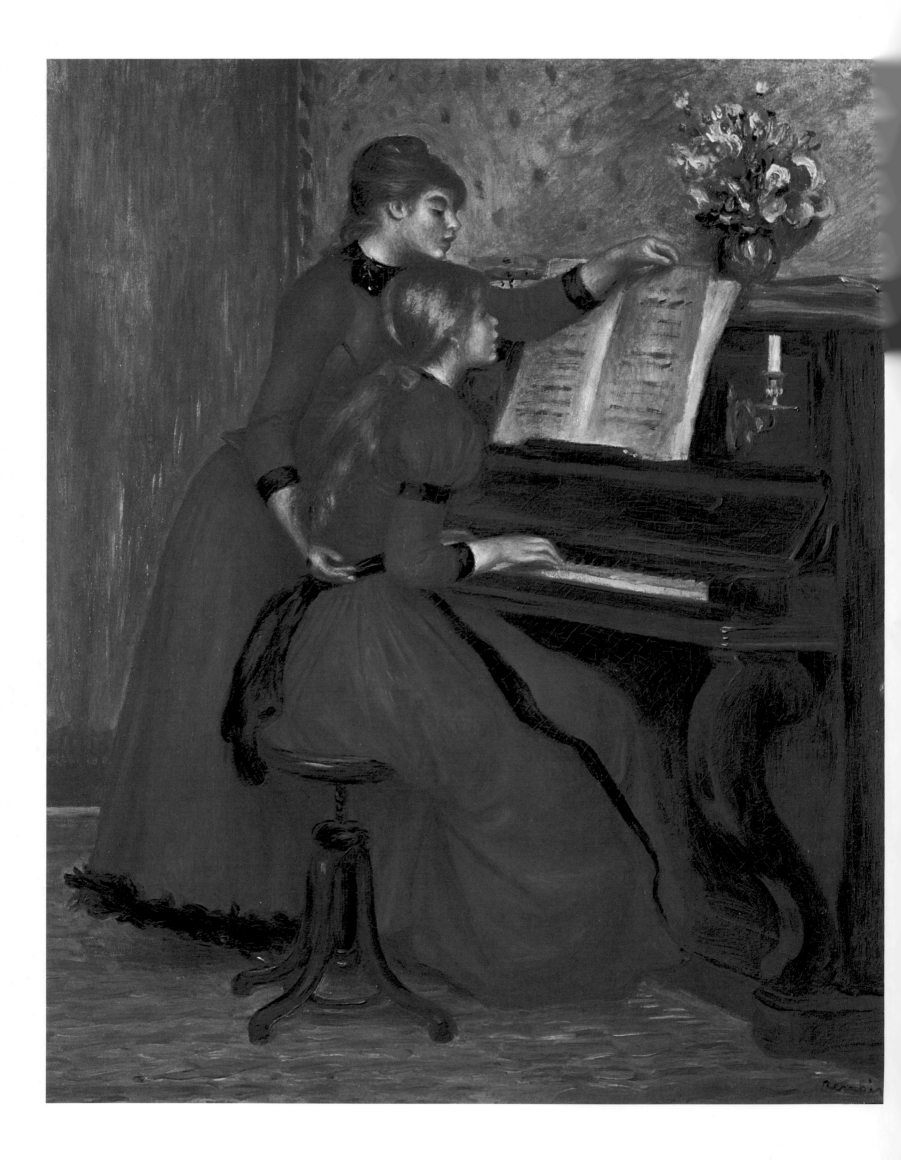

RENOIR
and his art

Keith Wheldon

Book Value International

NORTHBROOK, ILLINOIS

Frontispiece
Plate 1
Two Girls at the Piano
1888
$21\frac{1}{2} \times 17\frac{1}{2}$ in (54×44 cm)
Joslyn Art Museum, Omaha, Nebraska

The sitters for this picture were probably the
Mlles Lerolle who Renoir painted several
times, invariably using a similar colour
scheme dominated by black and red.

First published in the United Kingdom by The Hamlyn Publishing
Group Limited
London · New York · Sydney · Toronto
Astronaut House, Hounslow Road, Feltham, Middlesex, England

This edition published 1981 by
Book Value International, Inc.
A registered imprint of
Quality Books, Inc.
400 Anthony Trail
Northbrook, Illinois 60062 U.S.A.

© Copyright The Hamlyn Publishing Group Limited 1975

ISBN 0-89196-091-0

Printed and bound in Spain
by Graficromo, S. A. - Córdoba

Contents

The Early Years

Pierre-Auguste Renoir was born on 25th February 1841 at 4 Boulevard Ste Catherine, Limoges. He was the fourth of six children and joined a family of two brothers and one sister, one child being stillborn. His parents, Léonard, a tailor, and Marguerite, an ex-seamstress, lived with Auguste's grandfather François, a retired shoemaker and founder of the Renoir family. They did not stay at Limoges for long, and when François died on 28th May 1845 Léonard decided to move to Paris. Here there were greater opportunities for his tailoring business; and as his eldest son was showing promise as an engraver, Paris appeared to give him a better chance of being properly trained. They lived in an apartment in the Rue d'Argenteuil, which was in one of the poorer areas of the city between the Louvre and the Tuileries. In 1849 Auguste's younger brother Edmond was born, and the family circumstances had improved to such an extent that Léonard was able to open a separate tailor's shop in the Rue de la Bibliothèque, rather than have his customers call at his home.

Renoir's childhood was a happy one; he became the favourite of his mother and his older sister Lisa, who introduced him to painting by taking him to the Louvre when he was only nine years old. Early visits to picture galleries stirred his imagination, often to the detriment of his more formal education; his school teachers had cause to admonish him for his constant doodling in exercise books. He received further encouragement from a friend of Lisa's (later to be her husband) Charles Leray, who was an illustrator for the fashion magazines. The aptitude for drawing was not Renoir's only gift; he had a fine singing voice and was a member of the choir at the church of St Eustache in Les Halles. He was noticed and encouraged in his singing by the choir master Charles Gounod, who in 1851 had come to prominence as a composer with his first opera *Sapho*. In 1853 Gounod tried to persuade Renoir's parents to let him become a professional singer, but Léonard, who had only kept his family off the breadline by his own hard, solid work, thought a musical career too insecure.

Formal education did not play a great part in Renoir's life and in 1854 at the age of thirteen he left school, and like most boys from his background (at that time) he had to find himself a trade.

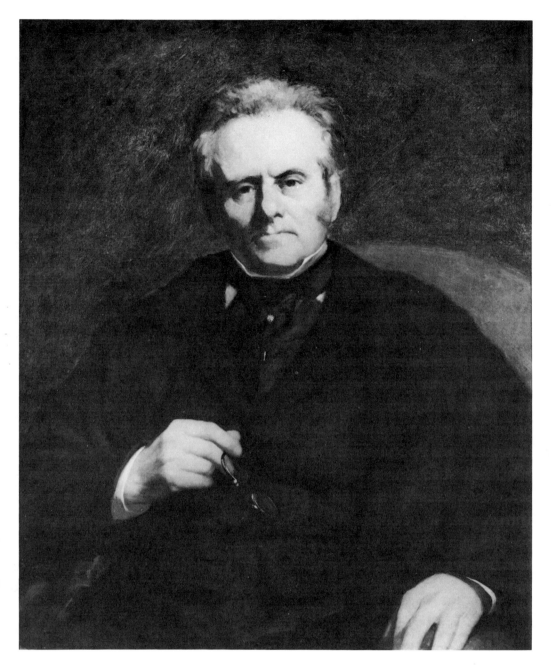

Plate 2
Portrait of William Sisley
1864
32 × 26 in (81 × 66 cm)
Louvre, Paris

This painting was accepted at the Salon of
1865. The contrast of light and dark tones
shows Renoir's early appreciation of Manet's
style. The background elements are reduced
to a minimum, a characteristic of many of
Renoir's portraits. The sitter is Alfred
Sisley's father.

To accommodate his growing interest in drawing it was decided
that he should become a porcelain decorator, and thus he joined
the firm of Lévy Frères. This choice was motivated by more than
Renoir's wish to utilise his talent: porcelain painting offered the
chance of learning a valuable and potentially rewarding skill, one
that had steady employment and a craftsman's self-respect as its
rewards. The conviction that painting was based on the
development of skill through hard work was to remain with
Renoir for the rest of his life. In 1915 he told his son Jean: 'The
only salvation is to work like a labourer, and not have delusions
of grandeur.'

Renoir worked at the porcelain factory for four years between
1854 and 1858. At first his job consisted of 'sprinkling tiny
bouquets on a white ground' for which he was paid five sous a

dozen, although this pittance was increased if the bouquets were larger, for the decoration of more substantial items. The speed at which he learned, and the facility with which he could carry out the fruits of his learning, earned him the title of 'Monsieur Rubens' amongst his envious fellow workers, who only gradually accepted him. After having proved himself by painting bouquets, he was allowed to tackle the profile of Marie Antoinette and eventually graduated to figure painting. In this he was aided by a book, *The Gods of Olympus by the Great Masters*, given to him by his mother. This contained plates illustrating the nude as interpreted by sculptors and painters of the Italian Renaissance, thus acquainting him with the Classical tradition at an early age. It remained a factor in his art throughout his life, which he was neither willing nor able to dispel. The porcelain he decorated was primarily for export and was passed off as Sèvres due to the proprietors of the firm fraudulently stamping the famous trademark on all their wares.

Although Renoir aspired to become a porcelain decorator, he became increasingly interested in 'serious' painting. In his lunch hour he used to rush to the Louvre to copy from the Antique, and to the Luxembourg where, in 1856, he became aware of the Barbizon painters. Towards the end of his life he told his son Jean: 'Rousseau amazed me, and Daubigny also, but I realised immediately that the really great painter was Corot. His work is for all time . . . I loved Diaz. He was someone I could grasp. I said to myself, if I were a painter, I would have liked to paint the way he did; and that perhaps I could have . . . And in Diaz's paintings you can almost smell the mushrooms, dead leaves and moss.'

On one of his lunchtime visits to the Louvre, whilst looking for a quick meal, he discovered Jean Goujon's *Fountain of the Innocents*. The sculpted reliefs on the fountain revealed the subtleties of flesh quality and drapery to him, as he recalled to Ambroise Vollard: 'Goujon gives you the texture of flesh and knew how to make drapery cling to the figure. Until then I hadn't realised how drapery brings out form. How it helps you to see the placing of the muscles.' Like many of the early influences on Renoir, the *Fountain of the Innocents* and the lessons it held for him were to reappear and be redefined in his art. Thus his statement about drapery and the placing of muscles is still as relevant to him, although in a profoundly different form, in the *Gabrielle with a Rose* (plate 86) of 1911 as it was when he first discovered it in Goujon's work in 1856. He found constant stimulus in certain themes and models to which he was always able to return, and in which he could find an almost infinite degree of variation and refinement throughout his life.

While he was still working at the porcelain factory Renoir
started to take lessons in the evening from an old porcelain
decorator, where he learned the rudiments of oil painting and
started to draw from the life. After he had finished working there,
he used to go to the theatre to see one of the many popular
melodramas of the time. His particular favourite was *La Dame de
Monsoreau* by Dumas *père*. The writings of the elder Dumas never
lost their charm for him, and he went to see revivals of *La Dame*
until ill-health prevented him from going out so much. In his
youth he also enjoyed the writings of Ronsard, Rabelais, and
François Villon. He was not over enthusiastic about the Romantic
excesses of Victor Hugo but he did admire the writings of
Théophile Gautier and Alfred de Musset.

In 1858 the porcelain factory went bankrupt and Renoir was out
of a job; mechanised painting processes were to make his craft
redundant. For a year he fought the tide of 'progress' by forming
a workers co-operative and painting and designing his own work.
This venture failed due to the public demand for the slicker finish
obtained by the mechanical process. For the rest of his life he had
an abiding dislike of mechanisation which he saw as killing the
slow, satisfying handwork that was the pride of the artisan. Thus
by the end of 1859 his dreams of becoming a porcelain painter

were dashed. The designs for his porcelain decorations were based on famous 18th-century paintings. In January 1860 he is first registered as having been given official permission to copy in the Louvre, where he could study the great masters of the Ancien Régime. He recalled: 'God knows how many times I painted *The Embarkation for Cythera*. The first painters I got to know were Watteau, Lancret and Boucher whose *Bath of Diana* was my first great love. All my life it held a privileged place in my heart.'

He also learned of the delicately erotic scenes painted by Fragonard. It was in the works of these 18th-century masters that he found themes which would form an important part of his *œuvre*: people enjoying themselves and relaxing in Watteau and Lancret, the joyous female nude in Boucher and Fragonard. He said of Boucher many years later: 'I've been told many times since that I ought not to like Boucher because "he's only a decorator". A decorator – as if that were a fault! In fact Boucher understands the feminine body better than most men. He painted young buttocks with little dimples exactly as they are.'

His next job, fan painting, was not very remunerative and to survive he had to take on odd jobs painting coats of arms for his brother Henri and decorating café walls. The latter, of which he thought he had done twenty in all, gave him a firm sense of large-scale composition; unfortunately none of these schemes are known to have survived. Eventually he turned to painting sun blinds to be used by missionaries in Africa. He bluffed his way into the job, not having any idea of the techniques involved, but he learned quickly and soon discarded the time-consuming process of 'squaring-up' the compositions, thus being able to turn out vast numbers of 'Virgins', 'Cherubims', and 'Saints'. He continued to copy in the Louvre and registered again in 1861. By this time his thoughts had turned to becoming a professional painter and he did a great deal of work in his spare time. A painting of 1861 entitled *Pierrot and Columbine* indicates that he was deeply influenced by Watteau and the Théâtre Italien, and a portrait of his mother of 1860 reveals his developing and vigorous painting technique, with its lively variation of brushstrokes creating a sharp plastic interest in the features. Thus at twenty years of age he was aware of Modernism as manifested by the painters of the Barbizon school, the delicate poetry of French 18th-century painting, and the monumental generalities of Antique and Renaissance Classicism. He spent most of his life trying to resolve these seemingly contradictory elements and harmonise them with the radical implications of Impressionism in an attempt to redefine but continue the great traditions of Western art.

The Years of Experiment

Renoir decided to follow the advice of his friends and try for a place in the Ecole des Beaux Arts. Laporte, his comrade at evening classes, backed him when he confronted his parents with this decision, emphasising the material advantages of such a step. Training at the Ecole would give him an opening to the Salon, where, if he succeeded, he would find buyers and a steady source of commissions, thus setting himself up in a well-paid profession which did not lack in social prestige. To convince his parents of the practicality of the idea Renoir was asked to paint a test picture entitled *Eve and the Serpent*. This was considered to show sufficient promise and his family supported him in his decision. Having now saved enough money from painting sun blinds to support himself whilst he studied, Renoir sat the entrance exam for the Beaux Arts and passed, coming sixty-eighth out of eighty successful candidates.

In April 1862 Renoir enrolled in the studios of Gleyre and Signol. Gleyre's studio was one of several private classes run by eminent Academicians which offered all the privileges of the official Beaux Arts courses but gave tuition at a slightly cheaper rate. Renoir's fellow students were not, on the whole, serious about painting, spending more time playing practical jokes than applying themselves to their work. He was considered a rebel because he kept to himself and worked hard, starting at eight in the morning and not leaving the studio until it closed in the evening. In August 1862 he met Alfred Sisley and they soon became friends. Sisley's background was very different from Renoir's; he came from a prosperous bourgeois family whose recently established wealth was based on the manufacture of artificial flowers. His parents had only reluctantly supported him in his wish to become a painter, and consequently he admired Renoir's determination to overcome the restrictions imposed upon him by poverty and unsympathetic teachers. Gleyre used to visit the studio once a week to criticise his students' work, and although he found Renoir's work 'incorrect' he had the sense to encourage him if only to help him overcome the deficiencies in his drawing.

Plate 4
Portrait of Mlle Romaine Lascaux
1864
20 × 26 in (51 × 66 cm)
Cleveland Museum of Art, Ohio (Gift of
Hanna Fund)

One of Renoir's earliest pictures of little
girls, a subject he returned to throughout
his life. In this rather formal portrait the
example of Spanish painting, and the
portraits by Velásquez in particular, appear
to have influenced Renoir's conception of
the picture.

It was in Signol's anatomy class that Renoir really came up against academic intolerance and bigotry. Signol, finding Renoir's drawing style too 'free', warned him, 'Be careful you don't become another Delacroix,' intending his comment as criticism. This was both an insult and an unwitting compliment to the young painter who had formed a profound appreciation of Delacroix's work during his hours of study at the Louvre. In spite of this harsh regime Renoir maintained that his two years of formal training had been of use to him. On being asked if he had learned much at Gleyre's he replied: 'A great deal. In spite of the teachers. The discipline of having to copy the same anatomical model is excellent. It's boring and if you weren't paying for it you wouldn't bother. But the Louvre is the only place to learn, really. And while I was at Gleyre's, the Louvre for me meant Delacroix.'

In the winter of 1862–63 Renoir met the painter Fantin-Latour, who had studied under Courbet and was a friend of Manet, Whistler and Degas. It was Fantin's exhortation, 'The Louvre! The Louvre! There is only the Louvre. You can never copy the masters enough,' that started Renoir on a serious study of the masters. His enthusiasm for Delacroix was encouraged by his friend, who admired Delacroix's recently finished (1861) murals at St Sulpice. In April 1863 Renoir registered to copy at the Louvre, and Fantin, who supplemented his income as a copyist, introduced him to Delacroix, Titian, Veronese, Giorgione, Rubens and Vermeer. These masters were to play an important part in the formation of Renoir's artistic vocabulary.

Sisley and Renoir did not remain an isolated clique at Gleyre's for long and in the winter of 1862 they became friendly with Frédéric Bazille and Claude Monet, who were also studying there. Bazille was to act as a link between the more traditional ideas of Renoir and the violent anti-academicism of Sisley and Monet. Monet's forceful personality and greater experience of painting made him the most radical of the group. At his home in Le Havre, he had studied with the painter Boudin, who taught him that it was only by looking at nature and responding to it directly that he would find inspiration. It was not long before it became obvious that Monet was wasting his time at Gleyre's; the academicism of the course was totally unsuitable for his independent temperament. Thus by the spring of 1863 he was advocating that he and his friends should leave and start painting in the fields and woods. Renoir's more academic outlook would not countenance such a wholesale rejection of the merits of teaching and the study of the Old Masters. He persuaded the group to persevere at Gleyre's for a little longer, and to copy in the Louvre during the winter months,

Plate 5
Potted Plants
1864
51¼ × 37¾ in (130 × 96 cm)
Collection of Oskar Reinhart 'Am
Römerholz', Winterthur, Switzerland

Accepted for the Salon of 1865, its size and
virtuoso handling show that Renoir thought
of the work as an exhibition piece.

although even then Monet would only look at landscapes.

Renoir shared a studio with Bazille in the winter of 1862–63, his parents having left Paris to live at the village of Ville d'Avray on the Seine. Through a distant relative of Bazille's, the Commandant Lejosne, they obtained an introduction to some of the most advanced literary and artistic circles of the day. The Commandant, a soldier by profession, took a keen amateur interest in the more liberal aspects of politics and the arts. He held small gatherings for painters, writers, critics, and politicians at his home, and Bazille and Renoir were occasionally invited. Here they met Baudelaire, Manet, Gambetta, Silvestre, de Banville, Gautier, and Arsène Houssaye. Several of these figures were intimately connected with the events of spring 1863, events that were to stimulate Monet, Bazille, Renoir and Sisley to work along far more independent lines than they had done hitherto.

Manet held a one-man exhibition of fourteen paintings at Martinet's Gallery in March. This was a daring move in itself as at this time the Salon was the most powerful exhibiting organisation, with the ability to make or break an artist's public reputation. Independent exhibitions of one artist's work were a relatively new idea, and private galleries were to be of fundamental importance to the growth of the avant-garde movement. Amongst the works exhibited at Martinet's was *Concert at the Tuileries Gardens* of 1861.

Manet and Baudelaire knew each other well by 1862, and the painter would have been aware of his friend's theories on the need for a school of painting that found its inspiration in modern life. Baudelaire wrote an article entitled 'The Painter of Modern Life' in 1859–60, in which he formulated his ideas on modernity and art; this was published in the autumn of 1863. In it he states that the artist should be 'the painter of the fleeting moment and all that it suggests of the eternal'. Although the particular artist he had in mind was Constantin Guys, by 1863 Manet fulfilled Baudelaire's ideal in a more profound way. *The Concert at the Tuileries Gardens* shows the high life of contemporary Paris, and its theme of people enjoying themselves was to be one of the main sources of inspiration for Renoir.

The Salon jury of 1863 proved itself to be devastatingly reactionary; it rejected three-fifths of the five thousand paintings submitted. This created such an outcry amongst the artists that Louis Napoleon (Napoleon III) saw fit to decree that there should be a 'Salon des Refusés', in which all the artists who had been rejected by the official Salon could exhibit if they chose. The 'Refusés' opened on 15th May and controversy raged around the works exhibited by Manet and Whistler. These events caused

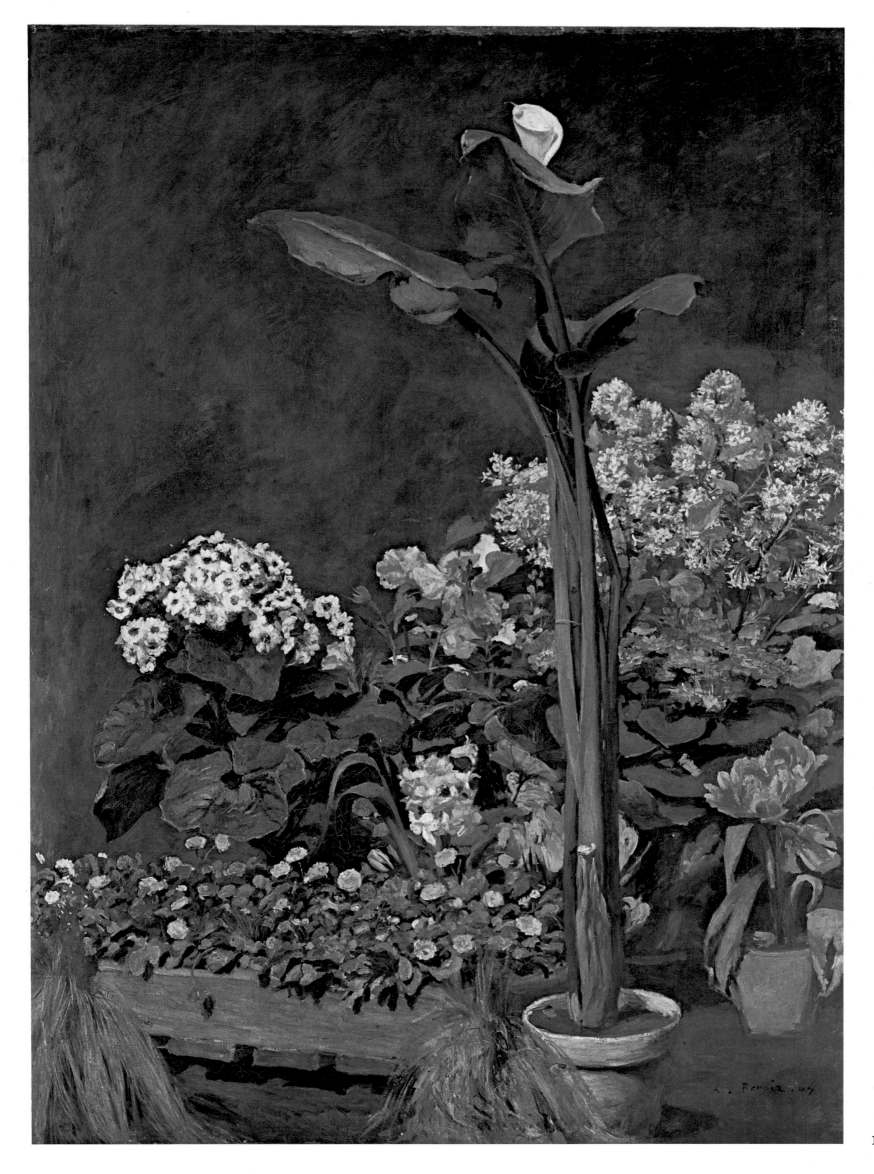

Plate 6
Portrait of Mlle Sicot
1865
48¾ × 38¼ in (124 × 97 cm)
National Gallery of Art, Washington D.C.
(Chester Dale Collection)

In this three-quarter-length portrait, Renoir
displays his ability to place a figure on the
canvas in such a way that it fills the picture
space and is the measure of it, without
losing any of his feeling for elegance and
subtlety.

Renoir and his friends to become even further disillusioned with
the teaching at Gleyre's, and in the summer of 1863 they went to
Chailly in the Forest of Fontainebleau with the intention of
sketching from nature. The Barbizon school of painters which
included Rousseau, Diaz, Millet, and the more independent Corot
had been sketching from nature in the Fontainebleau woods for the
last twenty years. Their work represented a step towards a greater
naturalism in that it confronted nature *in situ*, but they still
finished their paintings in the studio and worked within traditional
terms of reference. As Fritz Novotny states: 'The questions which
must be posed in connection with the so-called school of Barbizon
– or Fontainebleau – are these. How much direct experience of
nature could be expressed in the traditional language of the

Plate 7
Country Road near Marlotte
1865
13 × 19½ in (33 × 24 cm)
Collection of Mrs Norman B. Woolworth,
New York

This picture, influenced by the style of
Corot, indicates Renoir's debt to the master.
Renoir was to find him a constant source of
inspiration, making copies of his work well
into the 1890s.

Old Masters without abandoning its consecrated laws, and could
anything new be expressed through the medium of this language?'
By using the Barbizon school as one of the models for his work
Renoir was confronted with the same problems, although they
were more varied and complex because he was not primarily a
landscapist, and his solutions also had to apply to portraiture and
figure painting. It was in this expanded context that Courbet and
Manet were to play an important part in his development. His
work in the 1860s showed him experimenting with modernist
ideas and trying, as Manet had done in *Déjeuner sur l'Herbe*, to
utilise them in a traditional context.

Early in 1864 Gleyre closed his studio; this left the four young
painters free to develop in accordance with their interests. In

Renoir's portrait of William Sisley (plate 2), it is clear that he did not immediately throw off the more academic elements in his painting. The composition owes much to Ingres' *Portrait of M. Bertin*, although Renoir has chosen a slightly more elegant pose for his sitter. The dark tones of the background harmonise with the sitter's jacket, and the sketchily indicated chairback (another feature that relates to the Ingres) acts as a modulating element between these dark tones and the sharply contrasting light areas of the face and hands. The fluidity of Renoir's style reveals his natural ability to manipulate his medium, although the rather soft paint handling may owe something to the style of his friend Fantin-Latour.

When spring arrived Sisley and Renoir returned to Chailly to continue the outdoor work they had started the previous summer. During this visit Renoir met the painter Diaz, whom he acknowledged as having influenced his work at the time. Their meeting took place in unusual circumstances. Renoir, whilst painting in the woods, became the target of malicious fun for some Parisian tourists. They laughed at his porcelain painter's smock and started to upset his work, a fight threatened and Renoir was only saved by Diaz appearing at an opportune moment, wielding a large walking stick to ward off the aggressors. It has been shown that Renoir admired Diaz before they met and this predisposed him to accept the advice of a man, who, as Rewald states, was 'a fanatic adversary of line as well as slick academic technique'. He told Renoir that his painting was too dark and advised him that: 'No self-respecting painter should ever touch a brush if he has no model under his eyes.' The resulting change in Renoir's style was not as dramatic as he later maintained; there are no blue trees and violet earth in pictures of this period, but in *Clearing in the Woods* of 1864 the plastic quality of paint handling and dramatic light effects favoured by Diaz can be seen.

When he returned to Paris Renoir started to work on a series of portraits. The contacts he had made at the Lejosne meetings started to bear fruit, and Judge Lascaux, a frequenter of these gatherings and an ardent Wagnerite, commissioned Renoir to do a portrait of his daughter. The *Portrait of Mlle Romaine Lascaux* (plate 4) is one of the most outstanding of his early paintings. As Champa has pointed out, Renoir established a unique concept of pictorial space in this work. The figure is taken as a key to a series of subtle variations in tone, and the structure of the picture is unified with and subordinated to the key figure. The use of close value high tones necessitates a varied brushstroke to distinguish between the textural qualities of each of the elements, and at the

Plate 8
Portrait of Jules LeCoeur at Fontainebleau
1866
$14\frac{3}{4} \times 31\frac{1}{2}$ in (37 × 80 cm)
Museu de Arte Moderna de São Paulo, Brazil

The use of the abstract and ordering qualities of verticals indicates that Renoir had learned much of Corot's subtle art of composition. His triumph lies in the combination of these elements with the more naturalistic and robust features derived from Courbet.

Plate 9
Mother Anthony's Inn
1866
76 × 51 in (193 × 129 cm)
Nationalmuseum, Stockholm

Mother Anthony is shown with her back to
the viewer, the girl clearing away the
dishes is the servant Nana. Renoir's friends
Sisley and Jules LeCoeur sit round the table.
The wall in the background is covered
with 'frescoes' executed by the artists
visiting the inn.

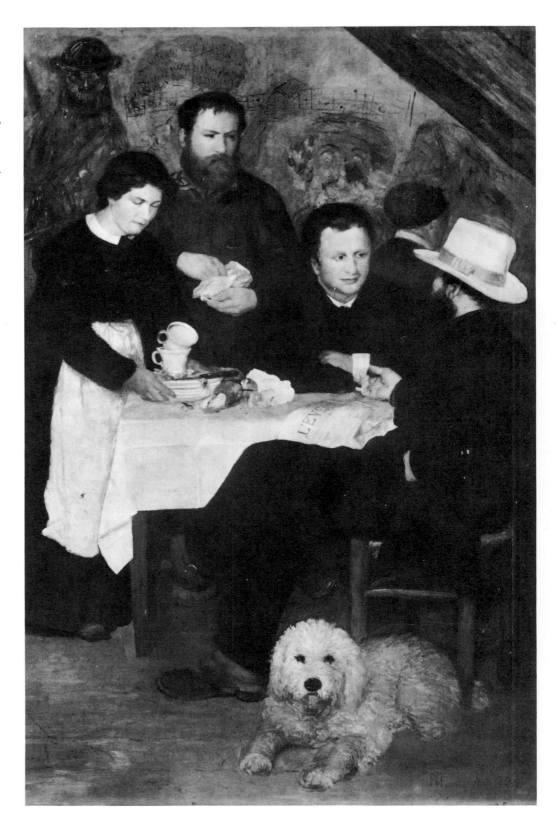

same time create a modulating unity of foreground which has a
quality akin to that of relief sculpture.

During the winter Renoir found himself without anywhere to
live. He was so poor, in spite of the portraits he had done in the
autumn, that he had to live in a succession of cold and dirty attics.
In these surroundings he started a flower piece, *Potted Plants*
(plate 5), which marks a return to the more contrast-orientated
style of the *Clearing in the Woods* and *William Sisley*. The brightly

coloured flowers stand out against the dark background. Renoir breaks new ground with the lighting used to create this effect, which is similar to that used in certain still-lifes by Manet of the same year. In both, the light sharply defines the object, emphasising line on the illuminated side and modelling on the side in shadow. Renoir has created strongly plastic, 'closed' forms which emphasise his drawing and his handling of colour and tone. These new elements were moderated in a portrait commission finished in the early months of 1865: the *Portrait of Mlle Sicot* (plate 6) is less dramatically lit, the figure being shown in an even light. What remains from the flower painting is the firm modelling of volumes and the competent ordering of picture space around the main element.

In May 1865 Renoir met Jules LeCoeur, an architect who had given up his studies to become a painter. He was persuaded by Sisley to go to Marlotte in the Forest of Fontainebleau where LeCoeur had a studio. The style of *Country Road near Marlotte* (plate 7) shows that the influence of Diaz had receded and that he was experimenting with pearly tones and delicate brushwork in the manner of Corot. Renoir met Courbet at Marlotte and as a result his style changed abruptly; the rather feathery brushstrokes of the *Country Road* are supplanted by more vigorous brushwork and an increased use of the painting knife. The *Portrait of Jules LeCoeur at Fontainebleau* (plate 8) was worked up from sketches made at Marlotte in the spring and finished in LeCoeur's Paris studio in the winter of 1865–66. This was not the first painting Renoir executed under Courbet's influence, but it is less confused than earlier attempts, and reveals how he assimilated elements of Courbet's technique and subject-matter without losing his own artistic personality. The predominantly green-brown colour range, the placing of the figure in the landscape, and the choice of a hunting scene as a portrait setting all indicate his debt to Courbet. His own style appears in the emphasised repetition of vertical elements and the use of a dappled light effect which superimposes delicate patterns of sunlight and shade on the more solid elements. Renoir used these pictorial devices in his famous picture *Le Moulin de la Galette* (plate 53).

The preoccupation with Courbet's technique did not last for long; years later he told Albert André: 'I painted two or three works with the knife following the procedure of Courbet. Then I worked with brushes in broad impasto. I was successful in some parts but I did not find it adaptable to reworking.'

He found such close adherance to another master's style restricting, but in the figure pieces executed between 1866 and 1869

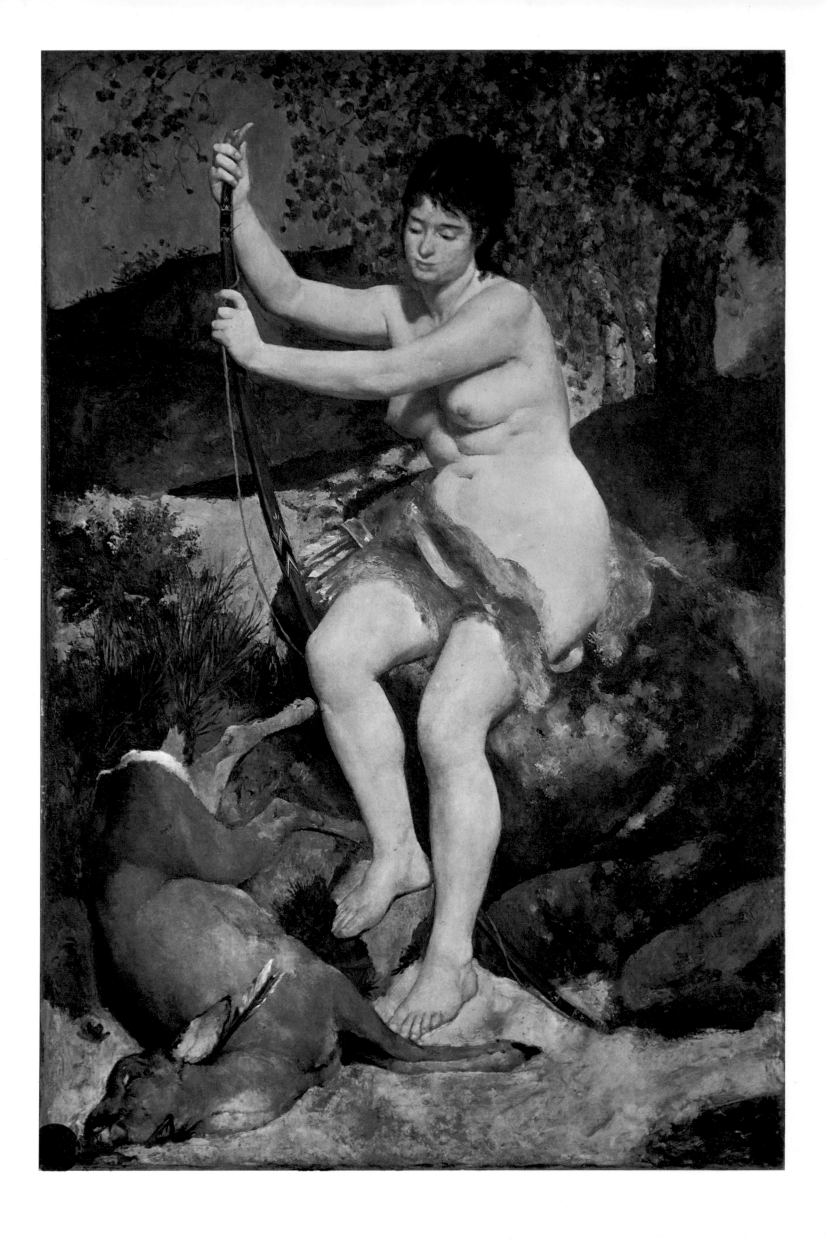

Courbet's influence is still present. In January 1866 he started *Mother Anthony's Inn* (plate 9) which was not finished until July, when he had moved to Bazille's studio on the Rue Visconti. The general conception of the painting owes much to Courbet's *After Dinner at Ornans*, in that it shows figures grouped round a table after a meal. Both works are Realist in that they show contemporary subjects and ordinary people in their everyday surroundings. Renoir shows his ability to compose groups of figures on a large canvas, using the conventional academic triangular format to achieve compositional unity. His painting

Plate 10
Diana: the Huntress
1867
76½ × 51 in (194 × 129 cm)
National Gallery of Art, Washington D.C.
(Chester Dale Collection)

The tension between the naturalism of the figure and the contrived pose, against an invented outdoor setting, indicates the crisis precipitated by Courbet and Manet. Renoir was unable to resolve this crisis between realism and tradition in his painting. The model is his mistress Lise Tréhot.

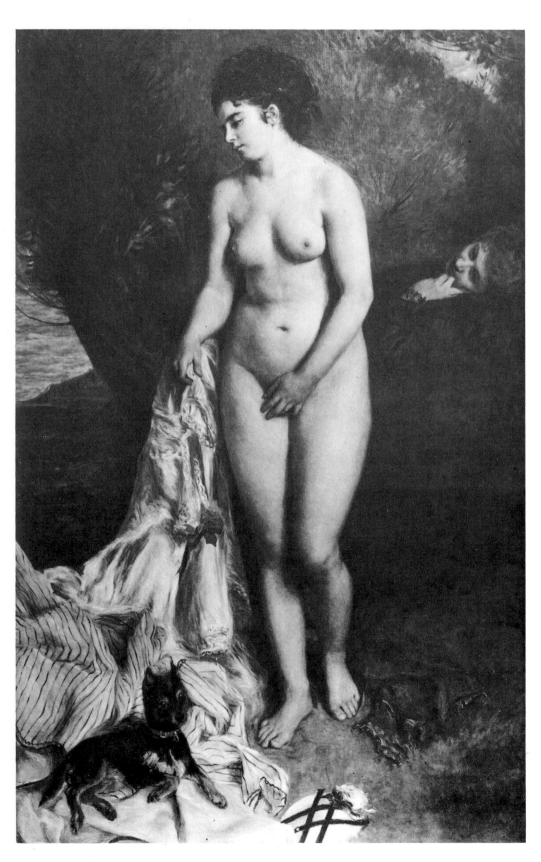

Plate 11
Bather with Griffon
1870
73½ × 46 in (187 × 116 cm)
Museu de Arte Moderne de São Paulo,
Brazil

The pose is derived from the Cnidian Venus. Another example of Renoir's inability to resolve the conflict between the Classical nude and its naturalistic setting.

23

Plate 12
**Portrait of Lise
(Lise with a Hat)**
1866
Barnes Foundation, Merion, Penn.

Plate 13
Lise Holding a Parasol
1867
71½ × 44½ in (181 × 113 cm)
Museum Folkwang, Essen, West Germany

The use of light on figures in outdoor settings has already been observed in Renoir's work, but the greater understanding of its action on form indicates that he had been inspired by Monet's open-air figure paintings. This picture was shown at the Salon of 1868.

style is varied and subtle and more naturally his own than the heavy impastos employed by Courbet; he shows great skill in the manipulation of brushstrokes to obtain textural variety within the unity of a perfectly modulated paint surface. The sharp contrast between the dark colour of the clothes and the white of the tablecloth indicates that he was aware of Manet's use of similar pictorial devices.

In 1867 Renoir started to paint in a more formal and monumental style, trying to utilise elements of Realism in a framework of more traditional figure painting. As Champa states, he was trying to manipulate his figures' 'potential to assume a role in the context of traditional imagery'. Renoir again looked to Courbet's work to find elements which would help him to achieve this fundamentally conservative shift in his style. It is interesting to note in this context that Renoir said of Courbet:

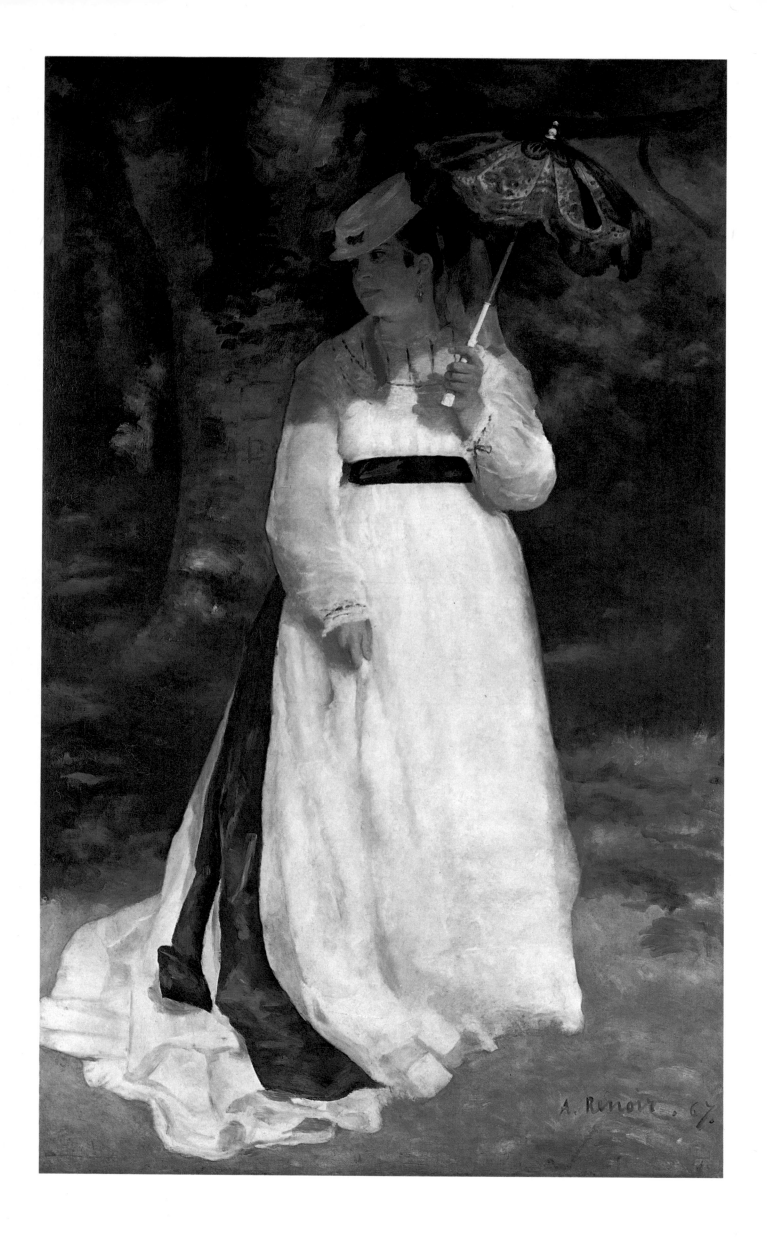

25

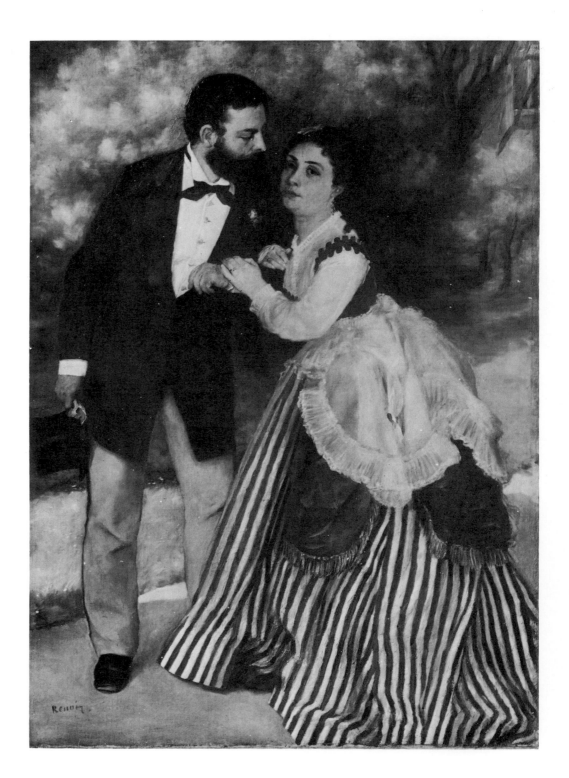

Plate 14
Alfred Sisley and his Wife
about 1868
$42\frac{1}{4} \times 30$ in (107 × 76 cm)
Wallraf-Richartz-Museum, Cologne

The poses skilfully combine intimacy and
formality, thus avoiding sentimentality.

'Courbet was the last of the traditionalists; Manet, he was the new
era in painting.'

In this series of monumental figure paintings Manet's influence
is ascendant in the more original works. Thus in *Diana: the
Huntress*, Renoir's rejected Salon picture of 1867 (plate 10), one
sees him trying to accommodate elements of Courbet's more
traditional realism with Manet's attempts to redefine traditional
pictorial imagery by daring formal innovation, in an academic
mythological scene. The concessions to academicism can be seen in
the complex pose of the nude and in the use of the necessary props
to make the literary image of Diana convincing. As Renoir said:

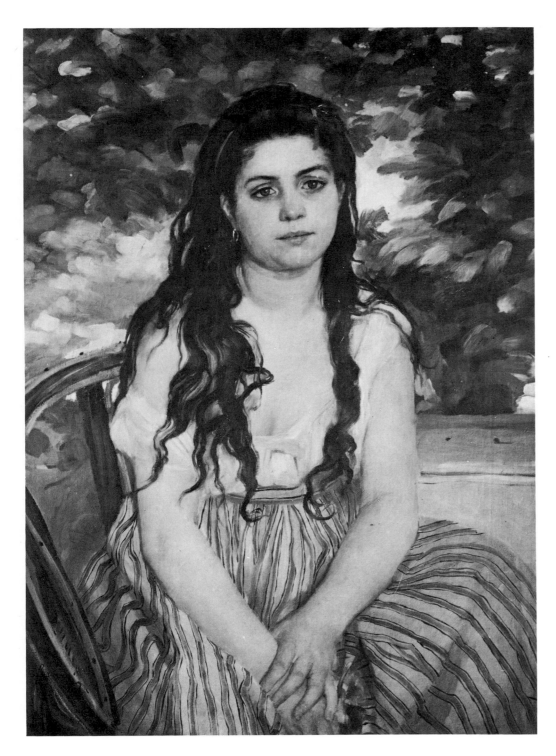

Plate 15
Lise: Summer
1868
$35 \times 24\frac{1}{2}$ in (89×62 cm)
Nationalgalerie, Berlin

The foliage of the upper half and the wall
in the lower part of the picture contrast
with and complement the skin tones. In
doing this Renoir is working on the
problems posed in Manet's painting.

'I put a bow in the hand of my nude and a dead doe at her feet and
I painted an animal skin across her crotch to cover what the
purists consider nakedness to mean. Then I renamed it "Diana".'

But it was these very concessions that were also the hallmarks of
Courbet's style; the complex studio pose of the nude set against an
obviously synthetic outdoor background, and the introduction of
a dead fawn, were all elements present in Courbet's work. Renoir
was trying to do what Manet had done in *Déjeuner sur l'Herbe*, but
by using Courbet as a model for his realism he confused the
essential contrasts and tensions between the old and the new that
make the Manet such a revolutionary painting. Courbet's

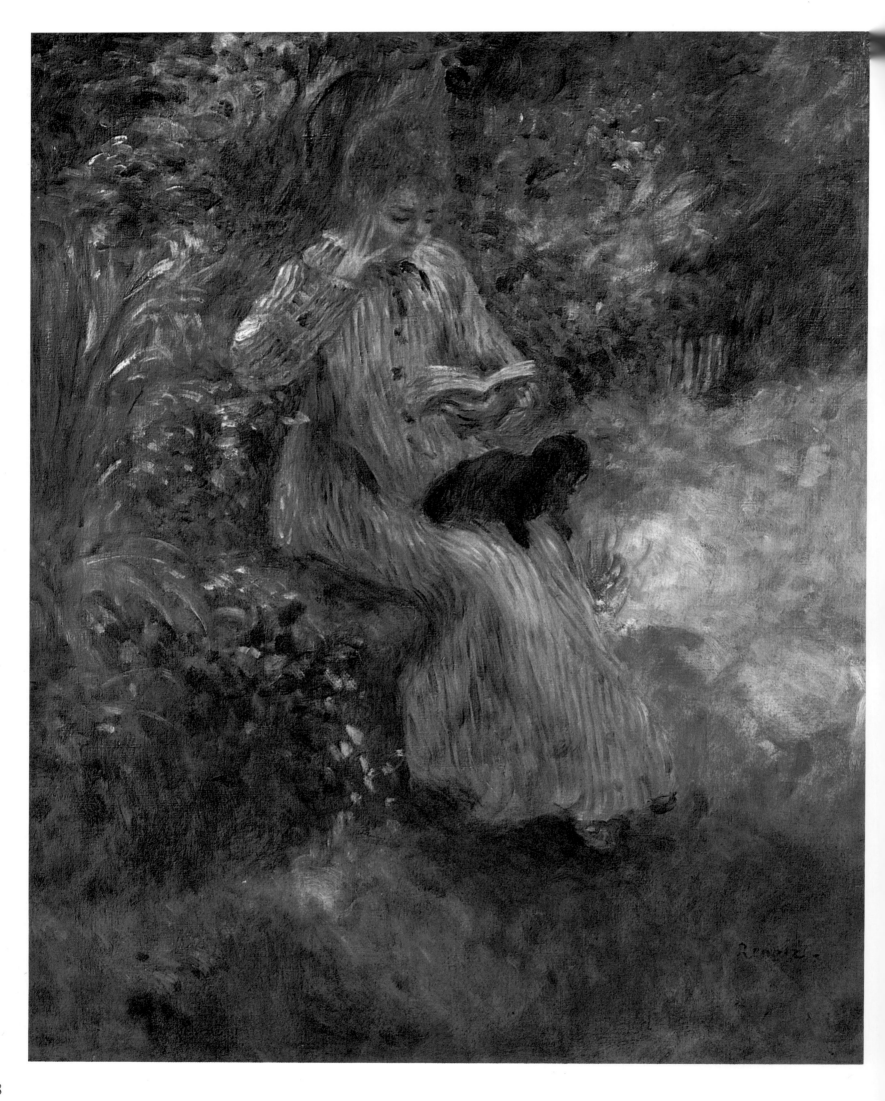

influence is present in another of Renoir's nudes, the *Bather with Griffon* of the winter of 1869–70 (plate 11). It appears that Renoir could only find a satisfactory precedent for the rather heavy beauty of his model Lise in Courbet's large, fleshy nudes. The setting for this figure, with its dark mass of foliage and the diagonally placed river, relates to Courbet's *Girls on the Banks of the Seine*. The influence of Courbet's art on Renoir's approach to painting was now tenuous; his work provided a model for a plausible excuse to place a formal nude in an outdoor setting.

When he was working on *Mother Anthony's Inn* in the spring of 1866 Renoir met Lise Tréhot who, as we have already seen, was to be the model for his figure works until 1872. She first appears in two paintings of 1866, *Lise Sewing* and *Portrait of Lise* (*Lise with a Hat*, plate 12), both executed in the open air at Chailly during the summer of that year. In these two pictures Renoir forms and begins to work out elements of the vocabulary that he is to use in a series of portraits painted between 1867 and 1870. This series, mainly of Lise, increasingly formalises the role of the contemporary subject, evolving into a poetic evocation of mood which transcends the limitations imposed upon it by contemporary dress. Renoir has, by placing figures in a pastoral setting, created a pervasive sense of poetic reality. The informal poses of *Lise Sewing* and *Portrait of Lise* were abandoned in the later works, and it is only in these early pictures that the debt to Corot's portraits can be seen. The distinguishing feature of these portraits, especially *Lise Sewing*, is the manner in which the foliage in the background has been generalised in an attempt to relate the figure to the supportative elements of the picture and simultaneously to define it, thus developing the concept of pictorial space formulated in the *Portrait of Mlle Romaine Lascaux*. The *Lise Holding a Parasol* (plate 13), painted at Chantilly in the summer of 1867, unites many of the apparently disparate elements seen in the works of the previous years. This full-length portrait is related to Monet's *Camille*, his Salon picture of 1866. The figure dominates the picture space, being at once delicate and monumental. The background supports and acts upon the figure, Renoir having used a similar generalising technique to that in *Lise Sewing*. The subtlety of the pose is enhanced by the action of dappled light on the white dress, which relates to the Jules LeCoeur portrait. The delicacy of the light reflected on the face, which is partially shaded by the parasol, and the glow of flesh through the diaphanous material of the sleeves bear witness to Renoir's magnificent technique. Zacharie Astruc the art critic, and a friend of Manet's, summed up the qualities of the painting when he said: 'The figure is well done and the

Plate 16
Young Girl Reading in a Garden, with a Dog on her Lap
1874
61 × 49 in (154 × 124 cm)
Collection of Sir Charles Clore

This work, which in its theme relates to a concept developed in the late 1860s, anticipates in its technique the paintings of the later 1870s, in which Renoir uses soft, dappled light and close tones to create pictorial unity.

Plate 17
Fête Champêtre
1868
$21\frac{3}{4} \times 10\frac{1}{4}$ in (55 × 26 cm)
Present whereabouts unknown

A sketch for part of a ceiling decoration
executed for Prince Georges Bibesco.

painting has great charm – accuracy of effects, gem-like delicacy,
unity, and sharpness of impression, excellent distribution of light . . .'

The portrait of *Alfred Sisley and his Wife* (plate 14) develops the
theme of *Lise with a Parasol*. The figures, similarly, dominate the
canvas, although Renoir introduces a somewhat mannered
elegance to their pose, reminiscent of 18th-century portraiture.
The drawing is tighter and the forms are more clearly defined
than in *Lise with a Parasol*, striking a compromise between that
and *Lise: Summer* (plate 15), painted in the summer of 1868.
This was Renoir's Salon picture for 1869; the model is shown in
an even light which clearly defines the forms, and as a consequence
Renoir lays greater emphasis on his drawing. This more academic
policy was deliberately cultivated by Renoir, who had been
alarmed when his Salon entry for the previous year had attracted
so much comment from avant-garde critics, Zola and Astruc in
particular, as he felt this would endanger his policy of making his
'official' pictures as uncontroversial as possible in the hope that
they would attract more clients.

The slightly winsome pose of the model in *Lise: Summer*, and
her rather titillatory décolleté blouse are reminiscent of the delicate
sensuality favoured by the last painters of the Ancien Régime:
Fragonard and Greuze. Similarly, the picturesque costume, and
the original title *La Bohémienne* have the quality of sham
Arcadianism preferred by late 18th-century court painters. The
reference to 18th-century art is an underlying theme in much of
Renoir's painting in the period 1866–68, and remained constant
until the end of the century. The concept is similar to that of
Watteau's parkscapes. One such picture is *Young Girl Reading in a
Garden, with a Dog on her Lap* (plate 16), one of the finest examples
of his 'Impressionist' period. The soft dappled light enhances the
mood of the painting which does not have the melancholy of a

Watteau but is suffused with an atmosphere of tender, self-absorbed repose. In April 1868 Renoir was commissioned by Charles LeCoeur, Jules' architect brother, to execute two ceiling decorations for a town house he was designing for Prince Georges Bibesco. Such purists as Monet would have shied away from this type of 'hired' work, but Renoir found it a joy. He told Vollard, 'Painting decorations has always been one of my greatest joys,' and he continued to paint decorative canvases throughout his life. A sketch for one of the Bibesco decorations survives, entitled *Fête Champêtre* (plate 17), and it shows how closely Renoir followed the style of Fragonard. The composition and billowing freedom of brushwork resemble the left half of his *Rinaldo and Armida*. After such a close study of 18th-century art it is not surprising to see the elegance and conceits of that period employed in Renoir's more characteristic works.

In the spring of 1868 Renoir and Bazille moved to a large studio in the Rue de la Paix where they were occasionally joined by Monet. They often went to the Café Guerbois in the evenings, where Manet presided over a congregation of the leading figures in the Parisian art world which included Astruc, Duranty, Silvestre, Duret, Guillaumet, Braquemond, Lejosne, Fantin-Latour, Degas, Zola, Guys and occasionally Sisley and Cézanne. The talk was all of painting direct from nature, but Renoir quietly

Plate 18
The Champs Elysées during the Paris World's Fair 1867
30 × 51¼ in (76 × 130 cm)
Present whereabouts unknown

The real theme of this painting is not the exhibition but people enjoying themselves in a park on a sunny day. Renoir has also caught the limpidity of the sunlit atmosphere.

31

Plate 19
Portrait of Bazille
1867
$41\frac{3}{4} \times 29\frac{1}{2}$ in (106 × 75 cm)
Louvre, Paris

Manet greatly admired this painting.
Renoir was honoured and wanted to give
it to him, but Manet insisted on buying it,
being fully aware of Renoir's poverty.

persisted in his admiration of Ingres' *La Source* and felt that he was
right in having 'continued what others had done – and much better
– before me'. This feeling for continuity is present in many of his
works, as is the influence of Manet. The monumental portraits,
Lise with a Parasol and *Alfred Sisley and his Wife*, employ his sharp
contrasts of black and white. In the latter half of 1867 Manet's
influence was even more prominent. Renoir had already painted a
view of the 1867 Paris International Exhibition, *The Champs
Elysées during the Paris World's Fair 1867* (plate 18), which in its

slightly raised viewpoint and choice of the road motif running in a flat arch across the picture was similar to Manet's painting of a related subject, *View of the International Exhibition 1867*. In two works executed in the winter of 1867 Renoir is very close to Manet. The *Portrait of Bazille* (plate 19) with its full and broad handling, and composition arranged on two flat planes which deny illusory pictorial space, is one. Renoir has chosen a clever and original viewpoint which further emphasises the flatness of the painting; by looking across the subject from the right he creates a slightly oblique view of the easel, thus eliminating the need to show it in trompe l'oeil perspective. This defines the limited space whilst also seeking to deny it. Renoir has taken the 'flatness' idea from Manet and developed its implication in an extremely subtle manner. Manet was painting his *Portrait of Emile Zola* at the same time as Renoir was working on the Bazille portrait, and it is interesting to note that the pose Renoir has chosen for his sitter is a variant, in reverse, of that used by Manet for Zola. Both portraits utilise picture frames to emphasise the flatness of the background and exploit the spatial ambiguity of objects observed from a slightly oblique angle to enforce this sensation.

The relationship of figure to background and the use of contrasted dark and light tones is explored by Renoir in his picture *The Clown* (plate 20). Its function as a signboard demanded that the masses should be clearly defined and that the colours should be bright and contrasted. He looked to Manet as his model and there is a striking similarity between *The Clown* and Manet's *Mlle Victorine in the Costume of an Espada* (plate 21). Both attempt to relate the dark mass of a clearly drawn figure to a neutral-toned background. This can only be achieved by a successful manipulation of modelling and values. Both artists fail to do this in some measure, although Renoir manages to create a unity between the clown's white face and the side of the ring. The white chair represents an attempt to unite the figure with the abstract qualities of the ring floor, but it merely emphasises the harshness of the tonal relationships. Renoir's clown does not jump out of the picture as Manet's figure does, but it is nevertheless uncomfortable in its relationship to the background. The *Lise: Summer* is Renoir's most successful solution to the problems arising from his study of Manet's work. In this context his statement that he 'continued what others had done' gains in significance. He not only continued and developed the work of others but worked out the implications raised in their work in an original and creative way. He is over-modest when he considers that others had done better; he was now an accomplished artist in his own right.

Plate 20
The Clown
1868
$53\frac{1}{2} \times 80$ in (136×203 cm)
Kröller-Müller Stichting, Otterlo

Renoir undertook to do this painting as a pot-boiler. It was intended as a sign for a circus, but the owners went bankrupt before he had time to finish it.

Plate 21
Edouard Manet
Mlle Victorine in the Costume of an Espada
1862
$65 \times 50\frac{1}{4}$ in (165×127 cm)
Metropolitan Museum of Art, New York (Bequest of Mrs H. O. Havemeyer, 1929. The H. O. Havemeyer Collection)

Renoir's *The Clown* is an attempt to overcome the problems of pictorial unity posed by this work. Both paintings fail to unify a monumentally drawn figure with a more freely painted background.

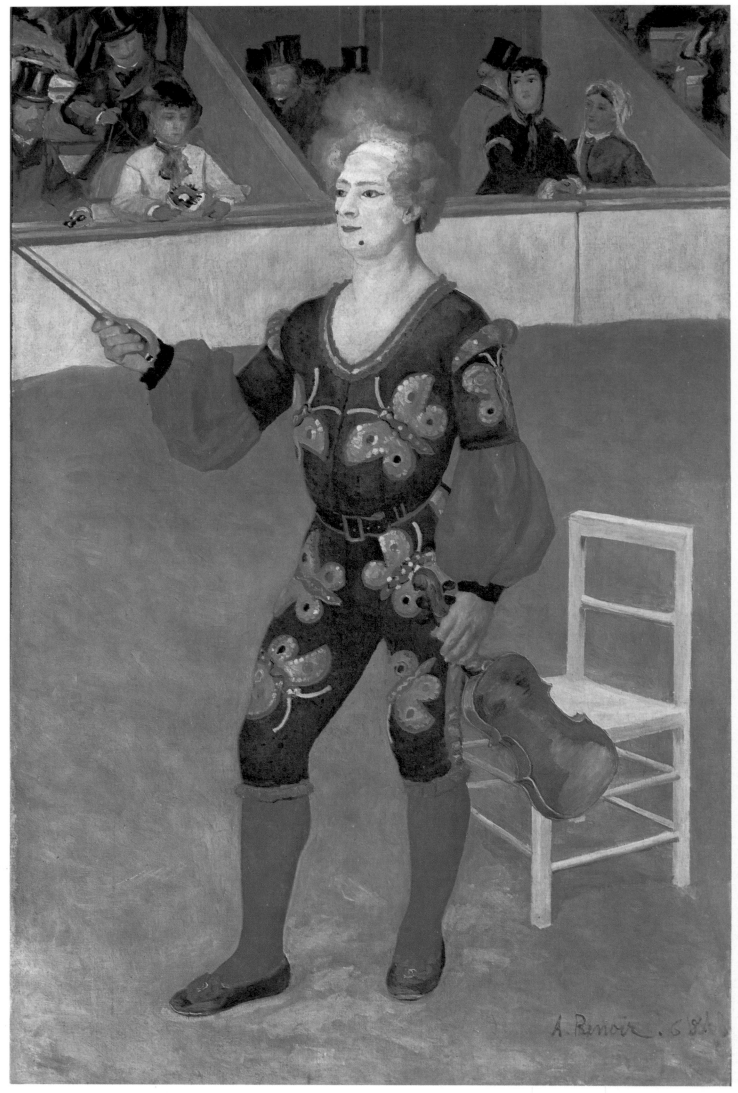

34

Plate 20 *see page 33*

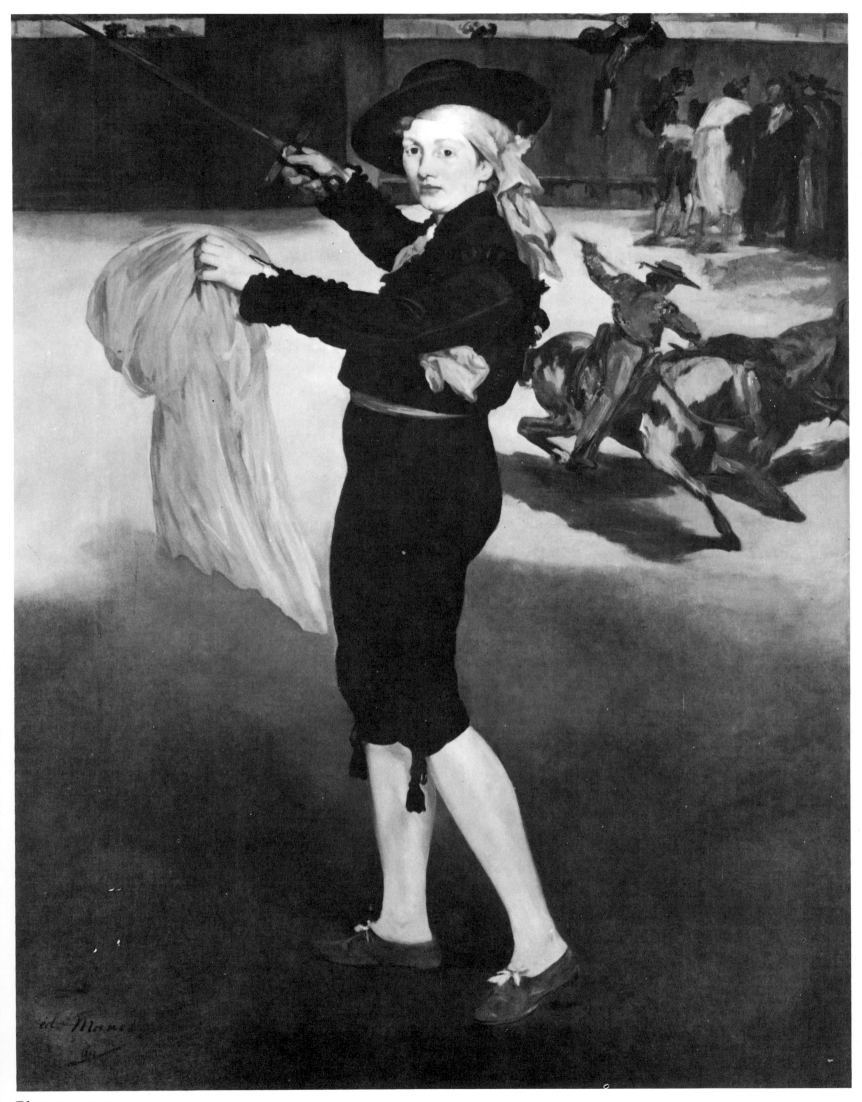

35

Plate 21 *see page 33*

Impressionism and Modern Life

The *Portrait of Bazille* of 1867 was a statement of Renoir's artistic life and intent. Its formal qualities have been demonstrated, but its iconographic elements, the subject of an artist working, and the choice of the picture shown on the wall are of importance. To deal with the subject first: Renoir and Bazille were sharing a studio and neither of them were well-off (although Bazille received a monthly allowance), thus they were each other's cheapest and most convenient models. Renoir's decision to show Bazille at work had not just been a matter of convenience though it was quite deliberate, and it is interesting to see that Bazille's *Portrait of Renoir*, painted at the same time, is by contrast an informal picture which gives no indication that the sitter is an artist. In the late 1860s and 1870s Renoir was fascinated by the world of art, and he had chosen the theme of artists talking and relaxing as early as 1866, in part acknowledging the theory of Realism. Renoir's awareness of 'the life of art' was fostered by his association with a loosely knit group united by varying degrees of opposition to 'official', academic art. This can be identified as the Batignolles group which based itself around Manet and the Café Guerbois in the years before the Franco-Prussian War of 1871. The Impressionists were a more closely knit sub-group within this larger context. Fantin-Latour's *Homage to Manet: A Studio in the Batignolles Quarter* of 1870 (plate 23) reveals that they were considered important members of the Batignolles faction, and that distinctions made on the grounds of personal style were not decisive. Zola, who was friendly with Manet and the Impressionists, gives an idea of the relationships within the Batignolles group in the early chapters of his novel *L'Œuvre*. The constant discussions and cross-fertilisation of interests all stimulated Renoir, who remembered this feeling of enthusiasm when he told his son Jean: 'We were all a group when we started out. We stood shoulder to shoulder and encouraged each other.' The fragmentation of the group was inevitable with so many individual talents involved, but whilst it did cohere the Batignolles group provided an intensely stimulating atmosphere for Renoir and his friends to develop their ideas.

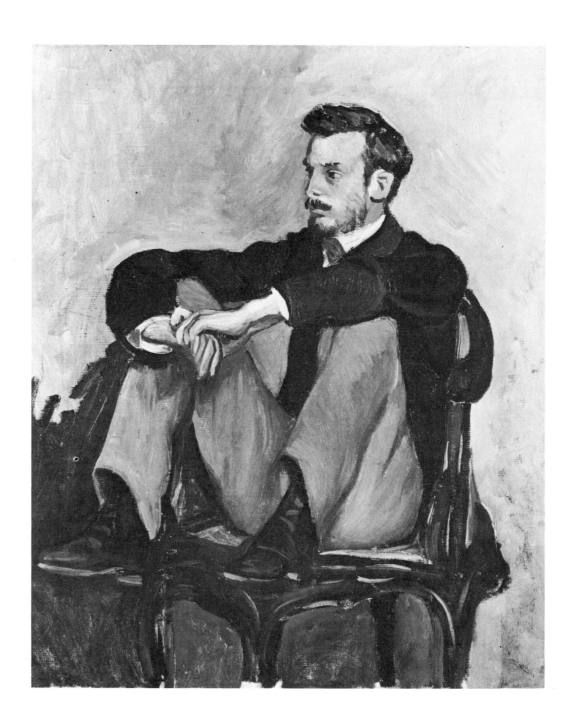

Plate 22
Frédéric Bazille
Portrait of Auguste Renoir
1867
24½ × 20 in (62 × 51 cm)
Museé des Beaux Arts, Algiers

The snowpiece behind Bazille's head in Renoir's *Portrait of Bazille* is the *Rue de St Siméon* by Monet, and it was his growing friendship with Monet that led Renoir to take a greater interest in landscape during the important years of 1868 and 1869. Mutual encouragement led them to the threshold of the Impressionist style developed in the 1870s. Their working methods were completely different, Renoir exploring many different possibilities simultaneously, and Monet methodically overcoming distinct sets of problems posed by his earlier work and observation of nature. But when they worked together, their differences were complementary. In 1867 Monet had painted a revolutionary series of townscapes utilising a high viewpoint to achieve startling compositional effects. In the wake of this series Renoir painted the

Pont des Arts (plate 24) in the spring of 1868. Here, the picturesque disposition of buildings against the skyline and the controlled use of pictorial space is reminiscent of Corot's views of La Rochelle. A characteristic that differentiates this and Renoir's other proto-Impressionist landscapes from those of Monet, other than differences of technique, is the emphasis he gives to painting people and their activities, a feature that Monet reduced to a minimum in the interests of creating a more uniform pattern of brushwork and colour.

It was in the winter of 1868 that Renoir and Monet started to work along similar lines. Taking his lead from Monet's snowpieces of the previous year, one of which he chose to include in the Bazille portrait, Renoir started to investigate the effects of reflected light and shadow on snow. It was the formal problem of light revealing its colour on a white ground that attracted Renoir to painting a snow scene, for he loathed the cold, and *Skaters in the Bois de Boulogne* (plate 25) is one of the very few works he did in this genre. In this work he adopts the high viewpoint used by Monet in the cityscapes of 1867. This has the effect of flattening the perspective and creating a pictorial structure built up of vertical and horizontal layers. Although the brushwork is characteristically subtle and varied Renoir introduces a new directness into his style, manifested in freer and more broken brushstrokes, as seen in the painting of the snow on the bushes at the lower left of the picture.

Renoir's morale was extremely low in the early spring of 1869; his painting was developing in a varied but apparently inconclusive manner, and he was not meeting with the success he

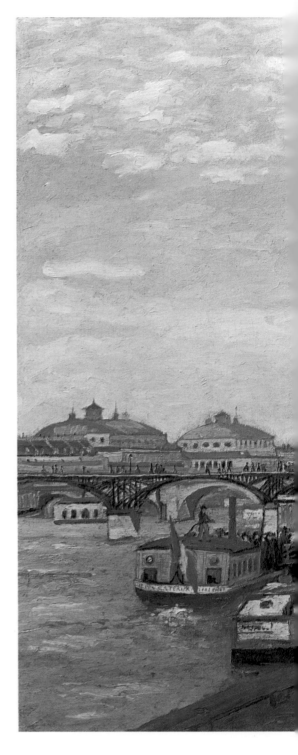

Plate 23
Henri Fantin-Latour
Homage to Manet: A Studio in the Batignolles Quarter
1870
68½ × 82 in (174 × 208 cm)
Louvre, Paris

Left to right: Scholderer, Manet, Renoir, Astruc, Zola, Maître, Bazille, and Monet. Manet asked that Renoir be shown close to him as an indication of his admiration and friendship for the younger artist.

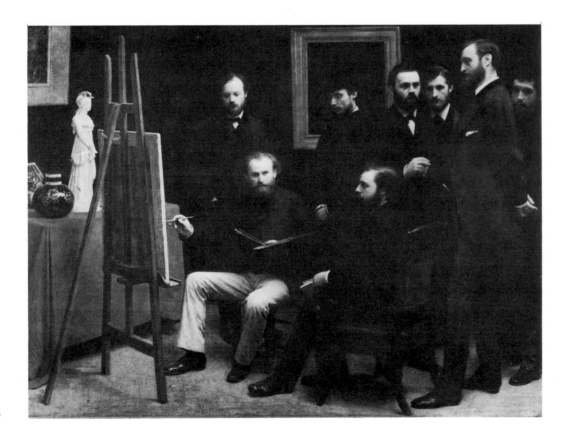

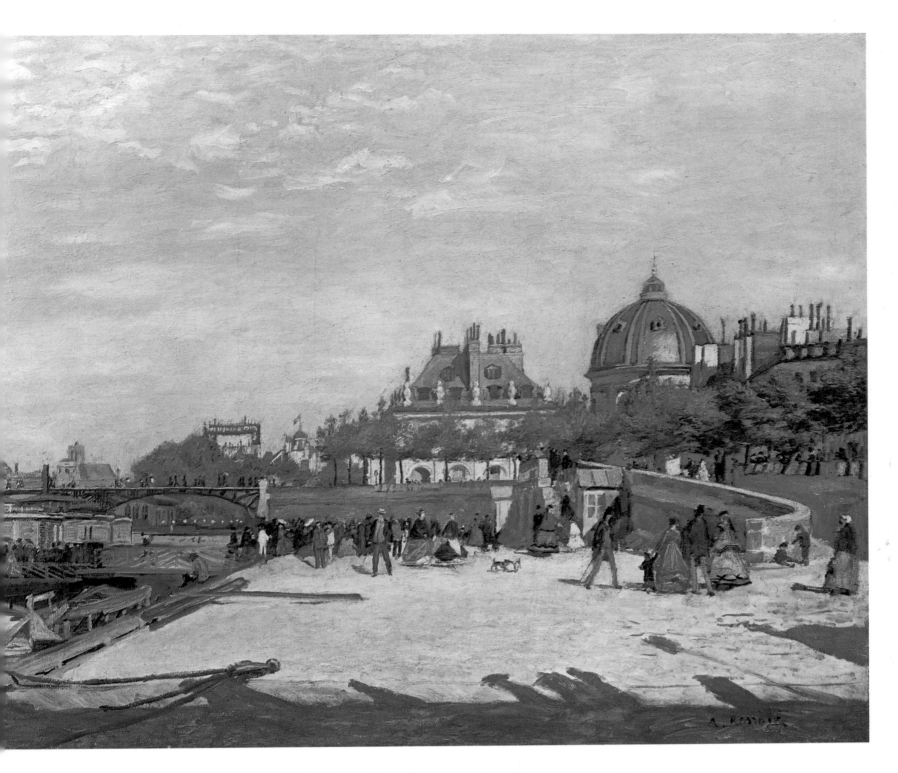

had hoped for. Renoir's need for his work to be appreciated must not be underestimated; although his primary motivation to work was the joy of painting, he felt that recognition of his talent was his due. This is shown in one of his comments about the Charpentier family who did so much to further his 'career' in the late 1870s: 'The family complimented me on my work. I was able to forget the journalists' abuse.'

In the summer of 1869 his confidence was boosted by renewed and closer contact with Monet who was painting at Croissy and Bougival on the Seine. Monet's work was going well, although he was so poor he was constantly having to ask Bazille for loans. He was now supporting his mistress Camille and their son Claude; Renoir kept them from starving by bringing food from Ville

Plate 24
Pont des Arts
1868
24 × 39¼ in (61 × 99 cm)
Norton Simon Foundation, Los Angeles

This painting can be related to *The Champs Elysées during the Paris World's Fair 1867* in the sparkling colours and the attention given to the figures.

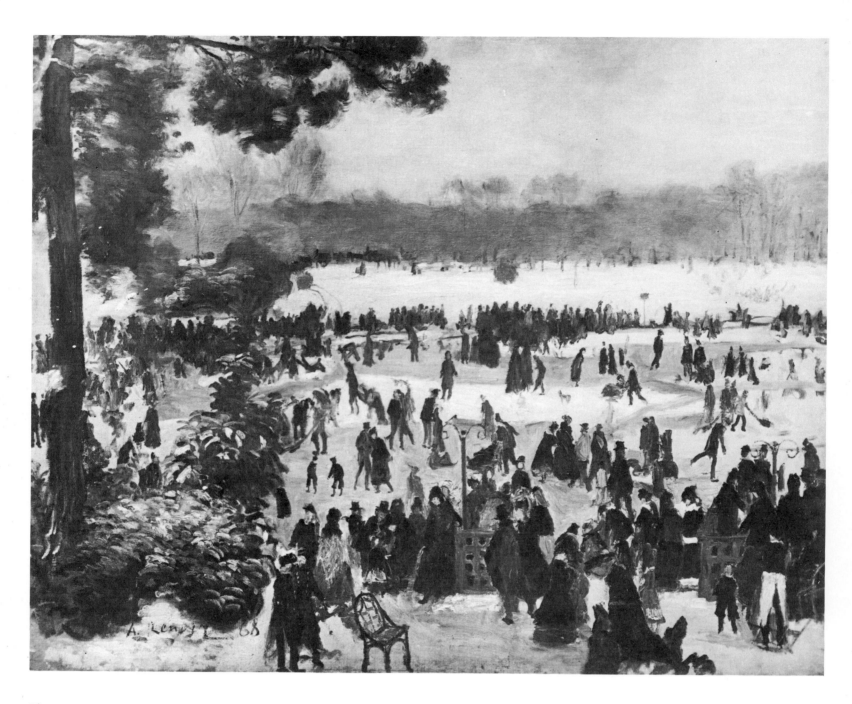

Plate 25
Skaters in the Bois de Boulogne
1868
$28\frac{1}{4} \times 35\frac{1}{2}$ in (72 × 90 cm)
Collection of Robert von Hirsch, Basel

One of Renoir's rare snowpieces; he loathed
the cold and regarded snow as 'the leprosy
of nature'. He has controlled the horizontal
elements of the picture by introducing the
strong vertical of the tree trunk on the far
left.

d'Avray where he was staying with Lise and his parents. Their
penury did not prevent them from starting a series of paintings at
La Grenouillère, a popular riverside spot where Parisians enjoyed
themselves at weekends; there was boating, swimming, eating and
dancing at the restaurant of Père Fournaise. Renoir later described
the atmosphere to Vollard: 'The Restaurant Fournaise was so
amusing, a kind of perpetual fête. And what a mixture of people.'

Monet was fascinated by the effect of light on water, and the
consequent disintegration of form. In the previous year he had
experimented with contrasting flat masses of high-value colour in
The River (plate 26). He developed the implications of this at
La Grenouillère, and in a letter to Bazille he stated that he was
'dreaming of a picture, the swimming area of La Grenouillère, for
which I have done some bad sketches, but it is a dream'. Renoir

was inspired by the force and direction in Monet's work which was, as Champa states, 'geared to produce the most powerful definition of optical interaction'. They worked side by side on a series of views, some almost identical, as in their two versions of *La Grenouillère* (plates 27, 28). Another view of this resort (plate 29) reveals Renoir's love of the joyful atmosphere at Père Fournaise's restaurant and his greater concern with the activities of figures in a landscape. The use of softer colours and smaller, more pointed brushstrokes characterise stylistic elements that are specifically Renoir's own. It is the element of style and the more lyrical interpretation of the motif that point to Renoir's concern with 18th-century painting at La Grenouillère. He has tried to create a unity between contemporary life and the timeless elements of poetry in the fêtes of Watteau and Fragonard. Monet was capable of working within himself when confronting nature, shunning the influences of the Old Masters and making a conscious break with tradition. Renoir did not see the necessity of this, feeling that his art should be additive rather than insular. The examples of the past were constantly relevant and gave increased depth and firmness to the new elements in his work. It was this synthesis which was both individual and revolutionary that brought Renoir's work closer in outlook to Manet's than any of the other Impressionists. Renoir had learned from Monet and painted the same subject, but emerged with an art that was unmistakably his own. As he told his friend Rivière: 'The quality of a work does not depend on its subject, because an artist looks at nature with a preconceived idea, and he interprets what he sees in accordance with this.'

Plate 26
Claude Monet
The River
1868
32 × 39½ in (81 × 100 cm)
Art Institute of Chicago (Potter Palmer Collection)

Monet has used the reflections on the water to flatten and contrast the colour masses, although as yet he has not started to use optical mixture techniques. The vertical emphasis of trees at the side of the picture stabilises the composition. Renoir adopted this idea in *Skaters in the Bois de Boulogne.*

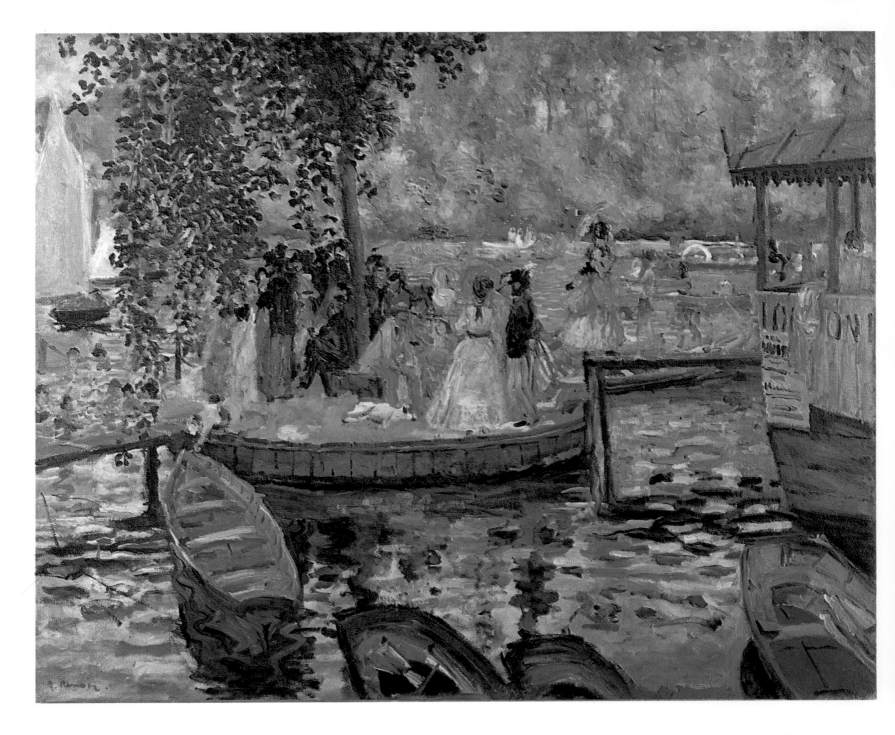

Plate 27
La Grenouillère
1869
26 × 31¾ in (66 × 111 cm)
Nationalmuseum, Stockholm

The viewpoint is almost identical to Monet's
(see plate 28) but Renoir has used finer, more
delicate webs of brushstrokes and more
pastel colours. He has eliminated Monet's
more forceful contrasts and created a
modulated paint surface which concentrates
masses by the varying intensity of brush-
strokes.

When Renoir returned to Paris for the winter of 1869–70 he
moved into a studio of his own on the Rue Visconti; this was
situated near the Café Guerbois and he spent many evenings there
talking and listening to Manet and the other members of the
Batignolles circle. Manet became very friendly with both Monet
and Renoir, and as we have seen both the young painters were
included in Fantin-Latour's *Homage to Manet: A Studio in the
Batignolles Quarter*. Renoir spent much of his time in the Louvre
studying Delacroix's paintings. The master's use of colour
attracted him, as did his exotic pictures of North Africa with their
striking colour combinations. The bright Algerian light that
Delacroix painted created intense combinations of whites, blues,
reds, yellows and greens, and the interest Renoir took in his work
complemented what he had seen in the increasingly startling
juxtaposition of primary colours that Monet had been

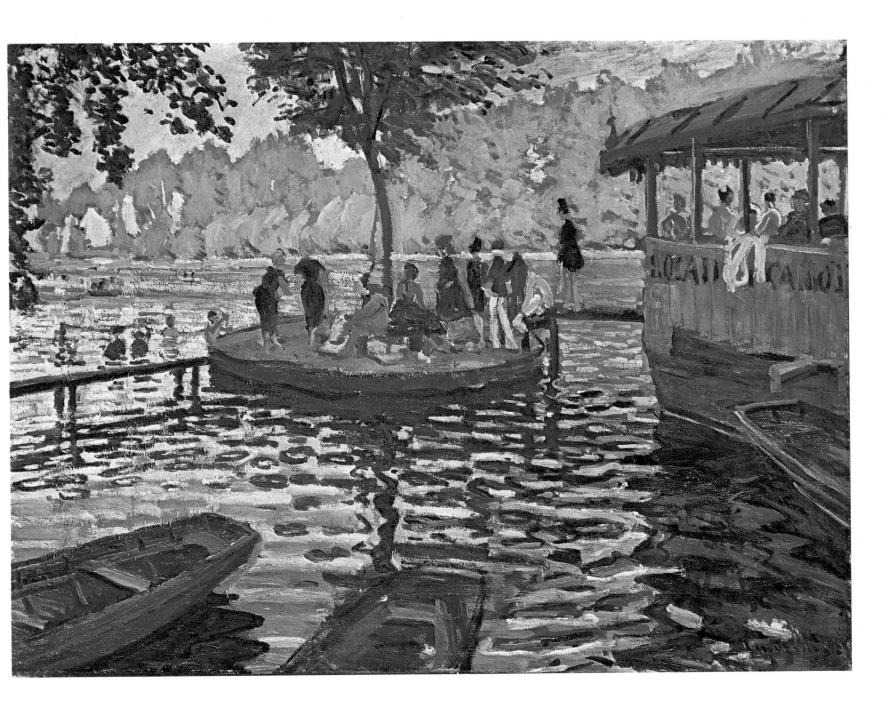

experimenting with at La Grenouillère. A series of paintings done
in 1870 and 1872 shows how Renoir adapted his own style to
learn from the master. In *Odalisque: Woman of Algiers* (plate 30)
he tries to accommodate the voluptuous monumentality of
Delacroix's harem pictures to his own rather heavy style of figure
painting. Renoir has obviously delighted in painting the rich and
varied patterns and textures of material which give him a chance
to display his virtuoso brushwork. Renoir comes closest to a
pastiche of Delacroix in his *Parisian Woman Dressed as Algériennes*
(plate 31), his own reworking of the *Women of Algiers* (plate 32)
which he called 'the most beautiful picture in the world'. His
composition, although satisfactory, is more conventional than
Delacroix's, and the poses of the three main figures look artificial
and forced in comparison with the originals. The portrait *Mme de
Portalis* of 1870 (plate 33) shows Renoir's response to Delacroix's

Plate 28
Claude Monet
La Grenouillère
1869
29¼ × 39¼ in (74 × 99 cm)
Metropolitan Museum of Art, New York
(Bequest of Mrs H. O. Havemeyer, 1929.
The H. O. Havemeyer Collection)

Monet has used purer colours than Renoir,
emphasising yellow and blue. His
brushstroke in comparison with Renoir's is
rather flat, which further emphasises his
greater use of colour contrast.

43

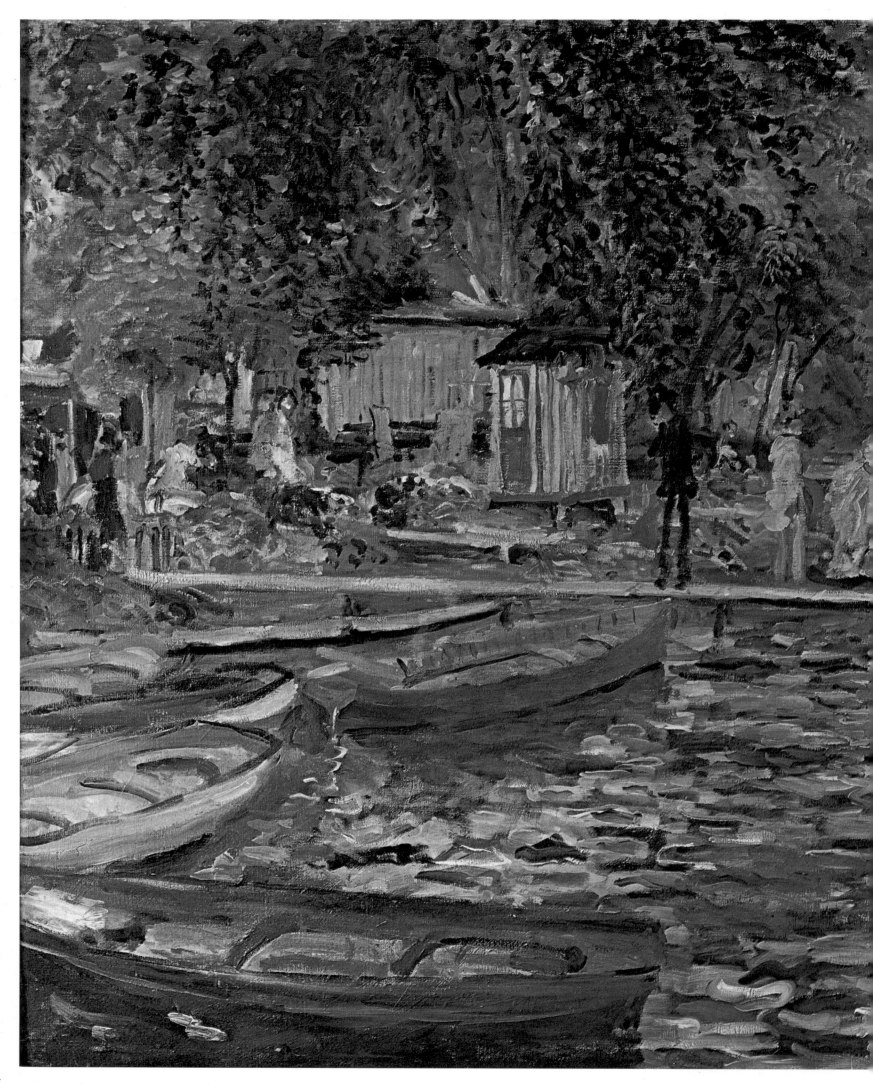

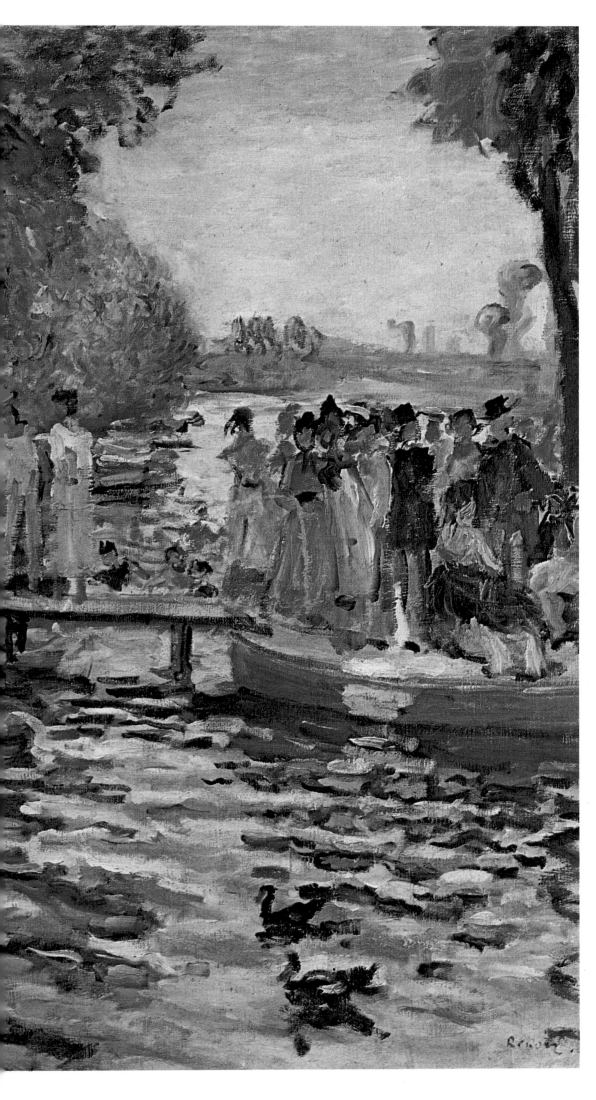

Plate 29
La Grenouillère
1869
$25\frac{1}{2} \times 36\frac{1}{4}$ in (59 × 92 cm)
Collection of Oskar Reinhart 'Am Römerholz', Winterthur, Switzerland

Ripples break up reflections on the surface of water; this encouraged Renoir (and to a greater extent Monet) to use broken strokes of pure colour to depict the effect. This was the empirical basis for the more scientific method of applying juxtaposed primary colours that formed the basis of the Impressionist technique.

45

Plate 30
Odalisque: Woman of Algiers
1870
27 × 48½ in (68 × 123 cm)
National Gallery of Art, Washington D.C.
(Chester Dale Collection)

Painted in the winter of 1869–70, this was
the first of Renoir's pictures influenced by
Delacroix. It was accepted for the 1870
Salon with his *Bather with Griffon*. The model
is Lise.

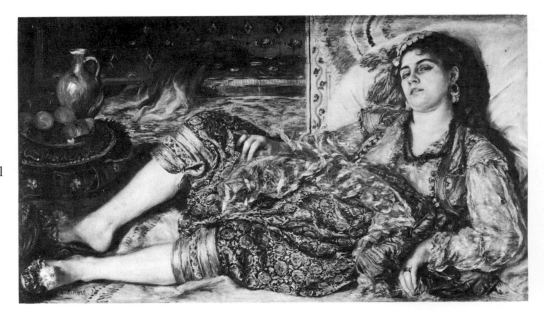

use of deep, sonorous reds, and the pose he has chosen is very close
to the latter's portrait of George Sand. This is very much a stylist's
picture in that Renoir employs magnificent brushwork to create
the volumes, softly modulating the plastic qualities of the paint
surface by the variety and changing intensities of his brushstroke.

Renoir's painting and social life were brought to an abrupt halt
when the Franco-Prussian War broke out in July 1870. Monet and
Pissarro fled to London, Cézanne retired to his parents' home in
the south, but Renoir felt it was his duty to join the army although
he was frightened of gunfire. His friend and patron Prince Georges
Bibesco offered to find him an easy post but he trusted to luck and
found himself attached to a regiment of cuirassiers. They were
ordered to Bordeaux and then to a village near Tarbes in the
Pyrenees, where not a shot was fired. Renoir caught dysentery
whilst in the mountains and nearly died, and it was only the
prompt action of an uncle who had him transferred to a hospital in
Bordeaux that saved his life. By 18th March 1871 he was back in
Paris; most of his friends had now gone to the provinces or abroad
to escape the fighting and did not return again until the Commune
fell. Throughout the civil war that raged between the Versailles
Government and the Paris Commune, Renoir continued to paint
as much as he could and his work shows no trace of the terrible
slaughter that was going on around him. Having links with
officials on both sides he managed to obtain safe-conduct passes on
either side of the firing line, passing from one side to the other
without too much difficulty; although once he was nearly
arrested for spying by some over enthusiastic Communards. One
of the few acquaintances from the old Guerbois circle to remain in
Paris was Edmond Maître, an amateur musician who

Plate 31
Parisian Women Dressed as Algériennes
1872
61¾ × 51¾ in (157 × 131 cm)
National Museum of Western Art, Tokyo

A tribute by Renoir to Delacroix's *Women
of Algiers*. The pose of the negress in the
background is almost identical to that of
a figure in the original.

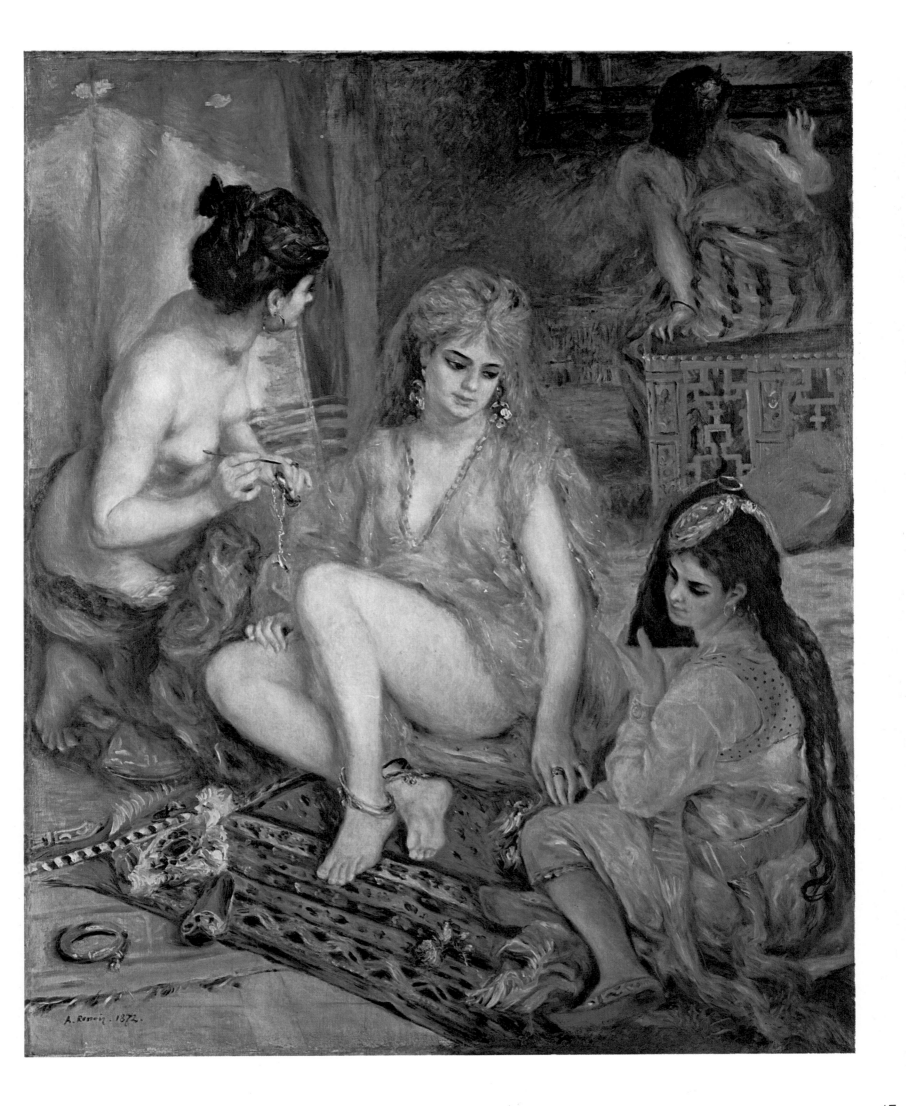

Plate 32
Eugène Delacroix
Women of Algiers
1834
$71 \times 90\frac{1}{4}$ in (189×229 cm)
Louvre, Paris

This magnificent painting towers above
Renoir's attempt to rework a theme that
had been given a near perfect manifestation
in the original. Renoir did not attempt his
Parisian Women Dressed as Algériennes in a
spirit of rivalry; he wished to learn from
Delacroix and thus improve his own work.

Plate 33
Mme de Portalis
1870
$31\frac{3}{4} \times 25\frac{1}{2}$ in (80×65 cm)
Fogg Art Museum, Harvard, Cambridge,
Mass.

Renoir has taken great trouble to balance
the light and dark tones in this
predominantly red picture, thus eliminating
the need for emphatic line to articulate
volume. This painting foreshadows the
virtuoso portraits of the middle and late
1870s.

commissioned Renoir to make a portrait of his wife. The
patterned wallpaper in this portrait relates it to a later work,
The Breakfast of 1879 (plate 34), in which Renoir tries to
integrate the elements present in his earlier work with an increased
sensitivity to light and atmosphere. The smoother style of painting
with its more unified brushstrokes was to develop in the 1870s
alongside the more characteristically moulded surface of his
Impressionist paintings. Renoir used the smoother technique when
he was painting in close, high-value tones, especially if the
background had more visual interest as a pattern than as a plastic
surface.

In the summer months of 1871, when Communard Paris was
being starved and slaughtered into submission by the Government
forces, Renoir managed to leave the city and stay with his parents
at Ville d'Avray. Here, and at the village of La Celle-Saint-Cloud,
he painted some pictures which can be characterised as modern
fêtes galantes. These and other works of this time show nothing of
the horrors of the civil war. They continue the blending of
contemporary and 18th-century elements to create a timeless world
seen in Renoir's paintings of La Grenouillère. In mood, intimate
and gallant, they are close to *The Walk* (plate 35), painted just
before the outbreak of the Franco-Prussian War. *The Henriot
Family* of 1876 (plate 36) shows Renoir returning to this theme,
but unifying it with the most vibrant elements of Impressionist
colour and brushwork. The use of comma-like brushstrokes for the

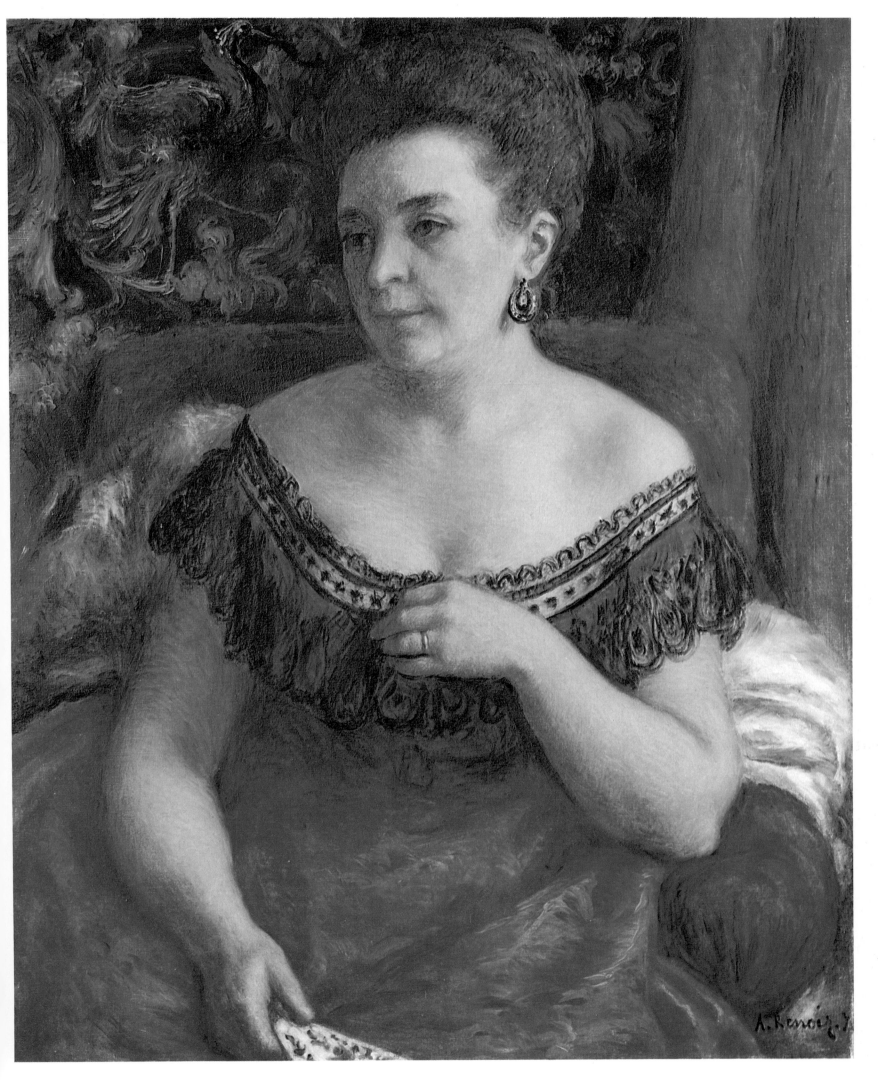

49

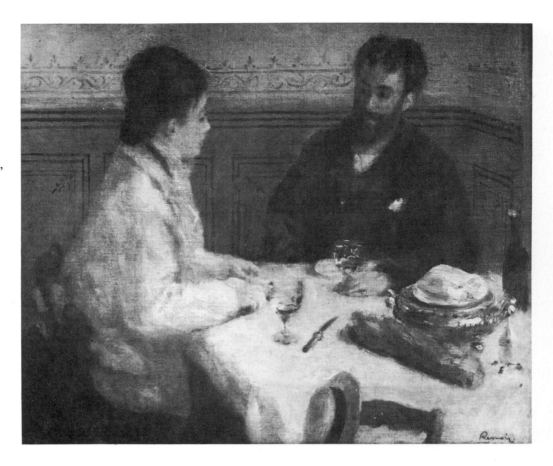

Plate 34
The Breakfast
1879
19¼ × 23¼ in (49 × 59 cm)
Barnes Foundation, Merion, Penn.

The use of a high viewpoint for this picture relates it to the earlier paintings influenced by Monet. In 1868–69 Monet had painted similarly intimate pictures of a family eating, but Renoir's more joyful picture ultimately owes more to an 18th-century precedent: Boucher's *The Breakfast*.

Plate 35
The Walk
1870
31¾ × 25½ in (80 × 65 cm)
Collection of Nate B. and Frances Spingold, USA

The rather self-concious elegance of the figures is similar to that found in *Alfred Sisley and his Wife* of 1868. Renoir's technique is now more suited to the portrayal of spontaneous action in the open air, thus eliminating the strain seen in the earlier picture.

leaves and grass had been developed in the paintings he had executed with Monet in the summers of 1872 and 1873. These emphasise the individual dashes of pure colour, which by their carefully related tonalities accentuate the autonomous plastic qualities of the paint surface.

In the spring of 1872 many of Renoir's old friends returned to Paris, but for him it was a time of parting: his relationship with Lise came to an end. As a parting gift he painted *Lise with a White Shawl*. Later in the year she married an architect and settled down to conventional domestic life. Renoir joined Monet who had returned from his travels in England and Holland. They both painted the Pont Neuf from the same viewpoint, although at different times, and the contrast between the two pictures reveals how the year's separation had caused their styles to drift apart. Renoir's *Pont Neuf* (plate 37) is altogether brighter; he has chosen a sunny day and the light creates strongly contrasting areas of high-value colour and shadow. The intensity of the light acts on the shadows giving them a luminosity which is expressed by his extensive use of blue in these areas. Monet chose a dull, wet day for his picture, his tones are muted and the contrasts less extreme. Renoir is less concerned with solid masses than Monet and he concentrates on the sparkling, fussy effects of brilliant sunlight. The emphasis on contrasts engendered by these effects was to

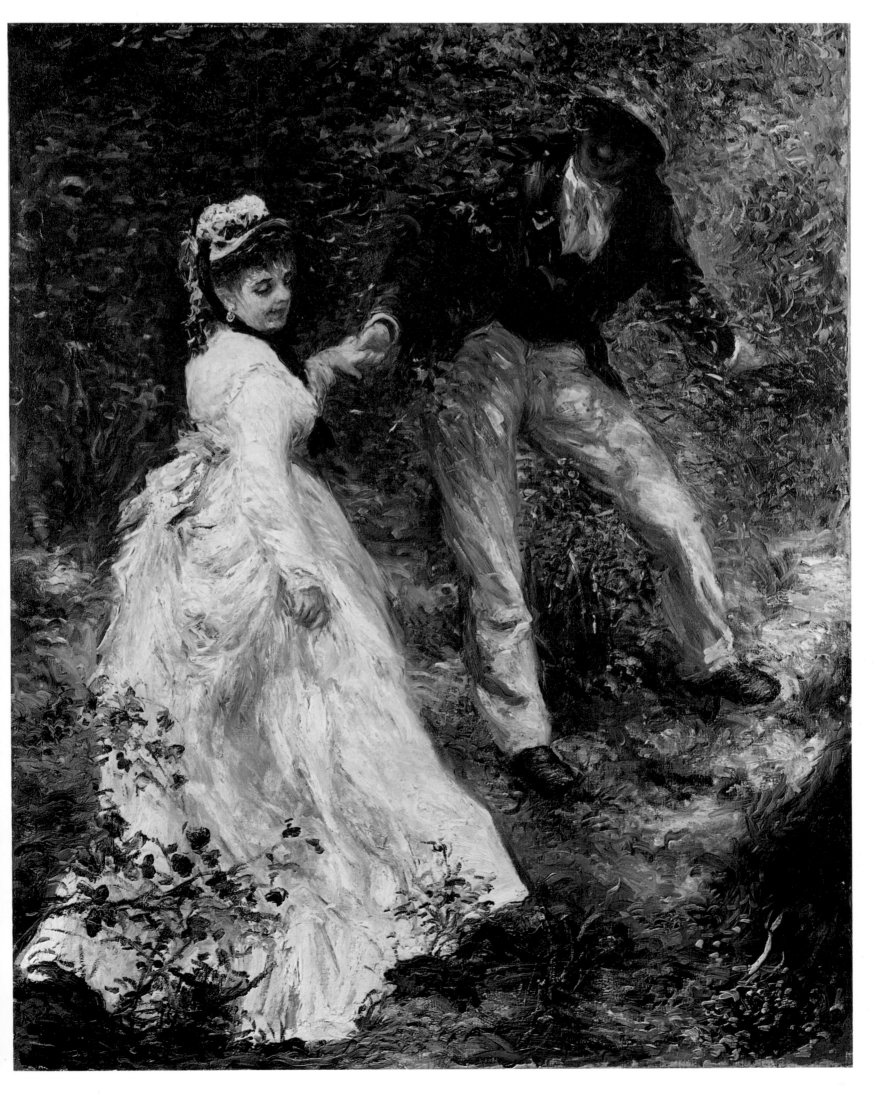

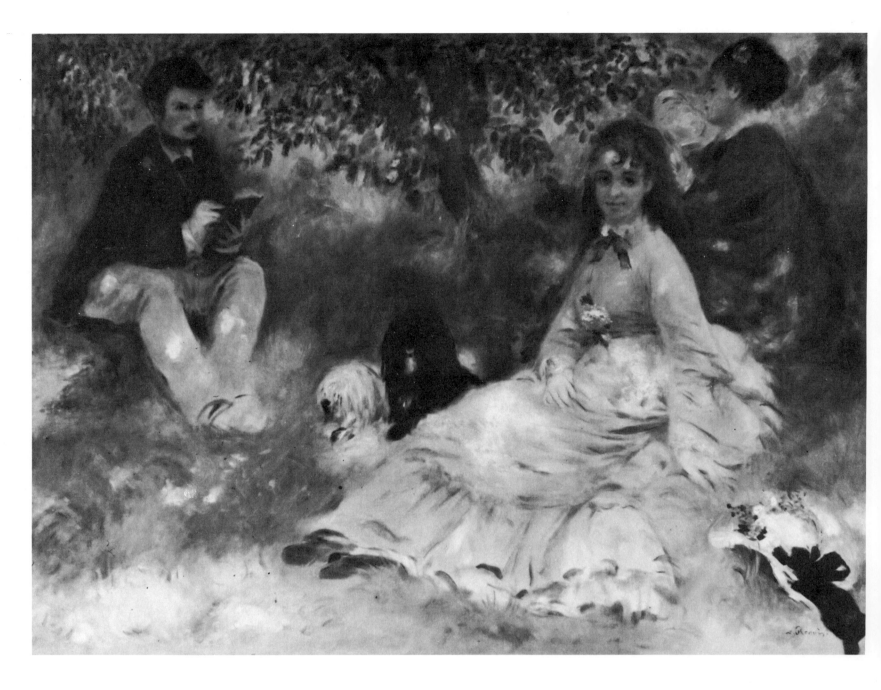

Plate 36
The Henriot Family
1876
45 × 64¼ in (114 × 163 cm)
Barnes Foundation, Merion, Penn.

Here Renoir achieved idyllic timelessness
without deserting the contemporary
subject, so important for the style of
painting.

characterise many of his landscapes in the 1870s.

Monet's trip abroad had increased his confidence in his powers
as a painter, and during his sojourn in London in 1870 he had met
the picture dealer Paul Durand-Ruel who enthused about his work
and promised to do all he could for him and his friends when they
returned to Paris. In the summer of 1872 Monet introduced
Durand-Ruel to Renoir; the dealer immediately bought the *Pont
Neuf* but he did not appreciate Renoir's talent as spontaneously as
he had Monet's. In the following year the dealer published a
catalogue of all the pictures he had in stock at his gallery and
although other Impressionists are mentioned, Renoir is omitted.
This coolness did not last for long and in the 1880s Durand-Ruel
did much to boost the prices of Renoir's paintings; they became
friends and corresponded frequently. Renoir admired his sense of
purpose, his picture dealing was motivated by a sense of
responsibility to the artists he supported, and he risked bankruptcy

rather than desert the cause of the painting he appreciated. He was not a radical man in outlook and as such was helpful to the Impressionist cause. As Renoir told his son: 'We needed a reactionary to defend our painting, which the Salon crowd said was revolutionary.'

The Batignolles group was beginning to re-form and Degas introduced Renoir to the critic Duret who immediately appreciated his talent and did all he could to introduce his art to a wider circle of patrons. These included the singer Faure and Dr Georges de Bellio, both of whom supported Renoir as much as their incomes would allow. In spite of all this Renoir was still very poor. At the end of the year he was turned out of his studio and had to leave several canvases behind in lieu of unpaid rent. Amongst them was *Lise Holding a Parasol* and it was only Duret's action of buying it from the landlord that saved it from destruction.

Renoir stayed with Sisley at Louveciennes for part of the summer, and later on went to stay with the Monets at Argenteuil. The latter were to establish the pattern of his summers for the next two years. He had grown to like Camille and Claude, and painted some of his most intimate and beautiful portraits using the Monets as his subjects. In this first summer he painted *Claude Monet Reading a Newspaper* (plate 38). The canvas is dominated by Renoir's modulation of dark blue tones relieved by the light reflected from the newspaper to create plastic interest on Monet's face. Renoir intensifies the frequency and tightness of his brushstroke on the points of visual emphasis; for instance, compare the large, free strokes of the background with the dense network of fine brushstrokes on the face and hands. The *Portrait of Mme Monet* of the same year (plate 39) is one of Renoir's most striking works so far. Camille is sitting on a sofa with her legs stretched out and Renoir has chosen a dramatically high viewpoint which has the effect of flattening her figure along the surface of the canvas. Thus a sitting figure is made to fill the vertical length of the canvas. His brushstroke is more varied and he uses blobs, diagonal dashes executed with a square-ended brush, and his characteristic network of fine, small brushstrokes to intensify the plastic interest of the paint surface.

After being turned out of the Rue Visconti studio Renoir found a new one at 74 Rue St Georges, half-way between the city and the village of Montmartre. It was here that he finished his Salon piece for 1873, *A Morning Ride in the Bois de Boulogne* (plate 40). This stiff and heavy work was rejected by the Salon jury; this upset Renoir as he had compromised his style in the hope of gaining

Plate 37
The Pont Neuf
1872
$29\frac{1}{4} \times 36\frac{1}{2}$ in (74 × 93 cm)
National Gallery of Art, Washington D.C.
(Ailsa Mellon Bruce Collection)

Renoir's brother Edmond stopped people who were crossing the bridge by asking them trivial questions. This gave Renoir enough time to paint them on the spot. By this method he achieved a directness and spontaneity of impression in both his figures and his rendering of light.

53

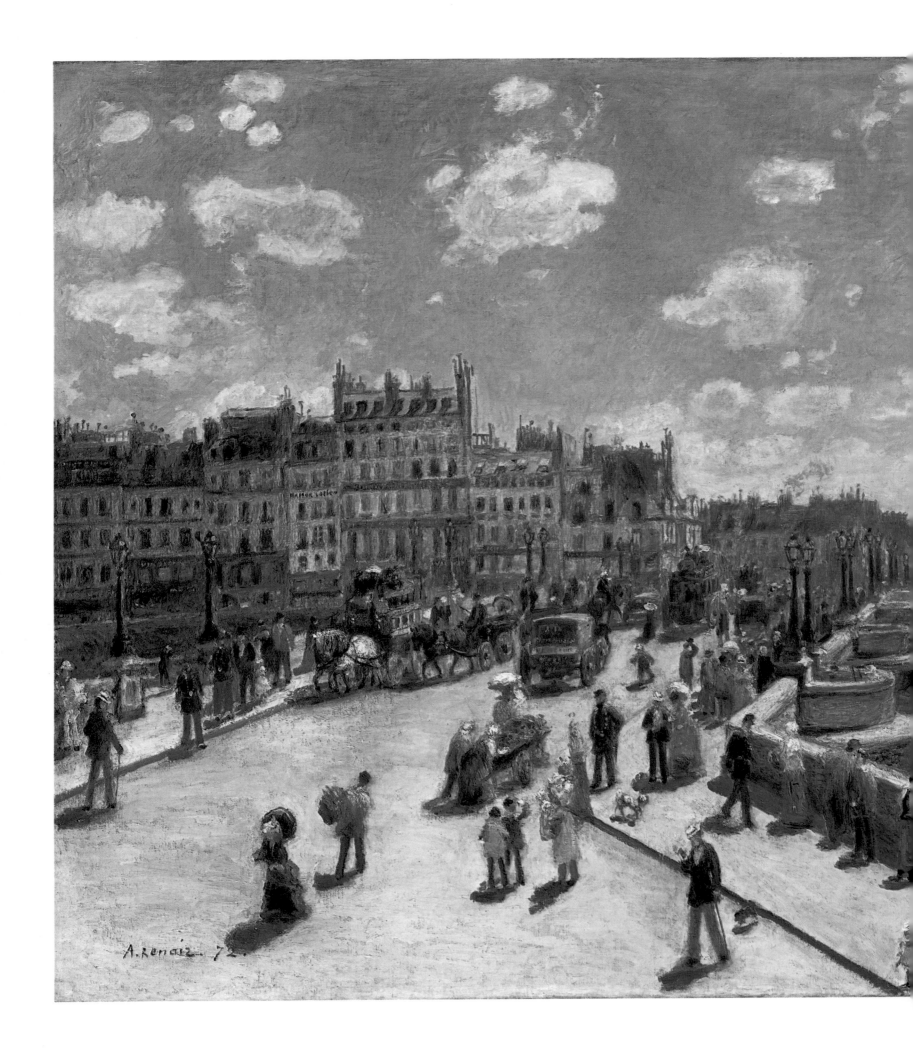

Plate 37 *see page 53*

acceptance. He had tried to consolidate his monumental style by giving an increased emphasis to solid mass and clear outline, but this only served to make the horses stand out too sharply from the background. Discontent with the prejudice of the Salon jury prompted Renoir and his friends to think of mounting an independent exhibition. They had been disgusted by Manet's success with *Le Bon Bock*, which they saw as a compromise after the revolutionary paintings of the previous decade. Renoir sympathised with Manet's motives; after all, he had done the same himself but had not been so lucky. Rather than compromise themselves Monet, Pissarro and to a lesser extent Degas, Renoir and Sisley, felt that it would be in their best interests to organise an exhibition of their own. The signs looked right for at least a moderate success. At the recent sale of the Hoschedé Collection the Monets, Pissarros, Sisleys and Degas had fetched a decent price. Durand-Ruel's stock catalogue had included some of their work, and in May Paul Alexis had written an article praising their work in *L'Avenir National*. This agitation and dissatisfaction led to the first Impressionist Exhibition in the spring of the following year. Meanwhile Renoir was forming his own circle of friends amongst the people who frequented the Café des Nouvelles Athenées which was superseding the Café Guerbois as a meeting place; these included Marcellin Desboutin, Georges Rivière, Cordey and Franc-Lamy.

In the summer Renoir rejoined the Monets at Argenteuil and the two painters worked side by side as they had in the previous year. Renoir painted *Monet Working in his Garden at Argenteuil* (plate 41), a statement of faith in outdoor painting and Impressionist method. Renoir makes greater use of red, blue and yellow on a white base. His brushstrokes have become smaller, taking the form of dots of pure colour superimposed on a web of comma-like dashes applied with a fine brush. Individually these brushstrokes do not define form, but when taken as a whole their variation of shape and pigment intensity forms an intensely plastic surface which, allied with the strict observation of tonal values, defines and creates form both in its own and in its illusionistic sense. Primary colours are laid on in their pure state and complementaries are juxtaposed; Renoir has arrived at a style of painting that conforms with Pissarro's statement that colour defines form, but he has taken it one step further and has made colour into form.

Monet and Renoir painted many beautiful landscapes in the summers of 1873 and 1874, some of which, years later, they could not tell apart. One such picture is Renoir's *Path Climbing Through Long Grass* (plate 42). Both artists painted almost identical views.

Plate 38
Claude Monet Reading a Newspaper
1872
24 × 19¾ in (61 × 50 cm)
Musée Marmottan, Paris

Plate 39
Portrait of Mme Monet
1872
24½ × 19¾ in (62 × 50 cm)
Sterling and Francine Clark Art Institute,
Williamstown, Mass.

This picture is probably based on Manet's
Berthe Morisot: Resting of 1869. The pose is
basically similar, but Renoir has taken
Manet's idea and developed its pictorial
consequences to the full. Note Renoir's use
of Japanese fans to balance the slightly
off-centre composition.

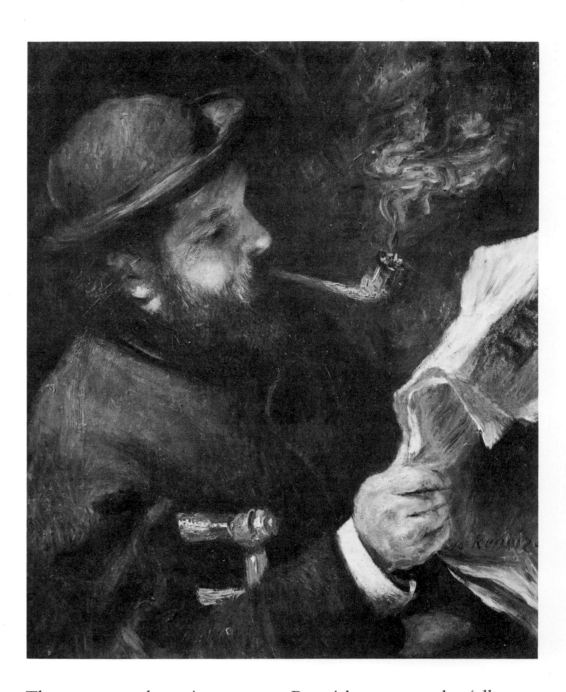

They appear to be trying to prove Renoir's statement that 'all
these elements of expression are nearly always at variance with the
achievement of good art'.

This anti-Romantic attitude which seeks to suppress overt
individualism did not, and could not, suppress the differences in
their styles. Monet uses flatter and more direct brushstrokes which
create a regular pattern across the canvas, whereas Renoir
emphasises clearly determined plastic values achieved by the varied
massing of his brushstrokes and pigment density. He painted a
series of landscapes in which he flattened pictorial space by dividing
the picture into horizontal bands, massed vertically, thus extending
the formal possibilities of his cityscapes. In *The Meadow* (plate 43)
his use of a high viewpoint to observe rising land causes the sky
to be relegated to a small strip occupying the top quarter of the
canvas. Perspectival recession is subtly indicated by the modulation

Plate 40
A Morning Ride in the Bois de Boulogne
1873
102 × 89 in (259 × 226 cm)
Kunsthalle, Hamburg

The models for this picture were Mme Darras, the wife of an army captain whom Renoir had met through Jules LeCoeur, and Joseph LeCoeur. Renoir finally broke with the LeCoeurs in the spring of 1873, after having disgraced himself by writing a love letter to Charles' 16-year-old daughter.

of the tones of yellow and green, enforced by the relative sizes of the two figures walking up the path, the central tree, and the barn. The even tonality of the sky with its mass of off-white cloud, relieved only by the occasional touch of blue, arrests the movement of the eye into the illusory space, or more accurately, pictorial depth, created by the aforementioned elements. In *The Harvesters* also painted at this time, Renoir further exploited the use of a cloudy, even-toned sky acting as a foil to perspectival recession; he achieved this by lowering his viewpoint to make the perspective more acute and at the same time creating more picture-space for the sky. Monet had also been experimenting with the controlled use of perspective in works like *The Field of Poppies*. He was to develop the idea of reducing the sky area by taking a high viewpoint and looking downwards, a motif hinted at in Renoir's *The Meadow*, and by completely eliminating it in works like *Boats in Winter Quarters at Etretat* of 1885. Thus in the summer

of 1873 the two artists not only painted the same subjects but also shared a considerable unity of interest when it came to picture-making. One of Renoir's best-known pictures, painted in the summer of 1873, is *Sailboats at Argenteuil* (plate 44) in which he illustrates his very individualistic use of Impressionist theory. The clash between his wish to avoid too great an emphasis on the 'elements of expression' and his own personality led to confusion in some of his statements. Thus he told his assistant Albert André: 'Theories do not make a good painting. They do not often help the insufficiency of the means of expression . . .'

In paintings like *Sailboats at Argenteuil* these antitheses are resolved and unified. He uses the complementary colours of blue and orange to full effect by juxtaposing them in the reflection on the surface of the water, and in his general application of colour he follows the theories used by the Impressionists; but looking at the composition and use of brushstroke one realises how individualistic Renoir's approach is. Monet, who had done a picture of the same subject, uses slightly more uniform tones, thus softening the impact of the white sail which takes up such a large area of the picture space. Renoir, on the other hand, exploits the possibility of the sail to the full; the bright sunlight catches the canvas, and he has painted it as a glowing mass of creamy white which forms a high-toned contrast with the rather bleached blue of the sky and water. He abandons his web-like masses of small brushstrokes to create a plastic colour form that conveys the effect he is looking at in nature. Thus for the sail he uses smooth long strokes of rich pigment, the trees are painted with a drier green pigment to recreate the dissolving effect of bright light on form. The water surface is painted with flatter, more uniform brushstrokes than he usually employs to create the effect of ripple-broken reflections. These are Renoir's own responses to the subject; theory has served his vision rather than dominated it.

When Renoir returned to Paris for the winter of 1873-74 he became involved in the continuing discussions about an independent exhibition. Manet would not join the young 'Intransigents' as the group was called before they acquired the title 'Impressionists', and he exhibited his picture *The Railway* at the Salon of 1874. The others thought the time was right for an exhibition of their own, especially as their main buyer Durand-Ruel could no longer help them, being on the verge of bankruptcy. Renoir played an important part in shaping the exhibition, putting forward moderate opinions to counter Pissarro's more extreme and authoritarian views. One rule that was enforced at all the Impressionist Exhibitions was that the

Plate 41
Monet Working in his Garden at Argenteuil
1873
19¾ × 42 in (50 × 106 cm)
Wadsworth Atheneum, Hartford, Conn.

One of the works in which Renoir comes closest to 'pure' Impressionism, adopting the 'scientific' palette under the influence of Monet and Pissarro.

exhibition when he states that to the majority of critics Delacroix was still considered a revolutionary. If this new group was to be taken seriously one could only arrive at the conclusion that they were subversive, as did Emile Cardon in a review published in *La Presse* for Wednesday, 29th April 1874: '. . . they are supposed to represent a new development in art. Velásquez, Greuze, Ingres, Delacroix, Théodore Rousseau, are banal: they have never understood nature . . .'

Most of the public did not take them seriously though, the consequences of such an attitude would be too disquieting, and they went to the exhibition for a laugh. The critical response was not totally unfavourable and dismissive; some of the more perceptive and advanced critics, such as Castagnary, were able to discern at least some of the features the Impressionists had in common. In a considered and prophetic article for *Le Siècle* of 29th April 1874 entitled 'Exposition du Boulevard des Capucines: Les Impressionnistes', Castagnary summed up at least one of the Impressionists' aims: '. . . if one wants to characterise them in a single word that explains their efforts, one would have to create the new term Impressionists. They are Impressionist in the sense that they render not a landscape but the sensation produced by a landscape.'

Most of Renoir's paintings were ignored, only *La Loge* (plate 45) received any mention and this, at least, was favourable. This picture illustrated the difficulties Renoir faced when he turned to figure painting. Conservative critics like Cardon saw Impressionist art as a rejection of the past, but in *La Loge*, which is both a tribute to the Old Masters and a development from them, Renoir shows that in his case at least the position is more complicated. He has fused new and old, and the result is something unique and exhibitors were not allowed to show at the Salon. Renoir disliked this idea, feeling that it struck a defiant attitude that would be more antagonistic than useful. Of the Impressionist group Pissarro, Guillaumin, Monet, Sisley, Renoir, Boudin, Cézanne, and Morisot exhibited. Degas led another faction of more academically inclined painters, thus bringing the total number of exhibitors to thirty. Renoir's brother Edmond compiled the catalogue, and it was he who first used the word 'impression' as the title of a painting. He could not persuade Monet to give a proper name to one of his views of Le Havre, and in desperation he entered it into the catalogue as *Impression: Sunrise*. The exhibition opened on 15th April 1874 under the corporate title of 'Société Anonyme des Peintres, Sculpteurs, Graveurs etc'. Georges Rivière, in his book on Renoir, makes a perceptive comment about the response to the

Plate 41 *see page 59*

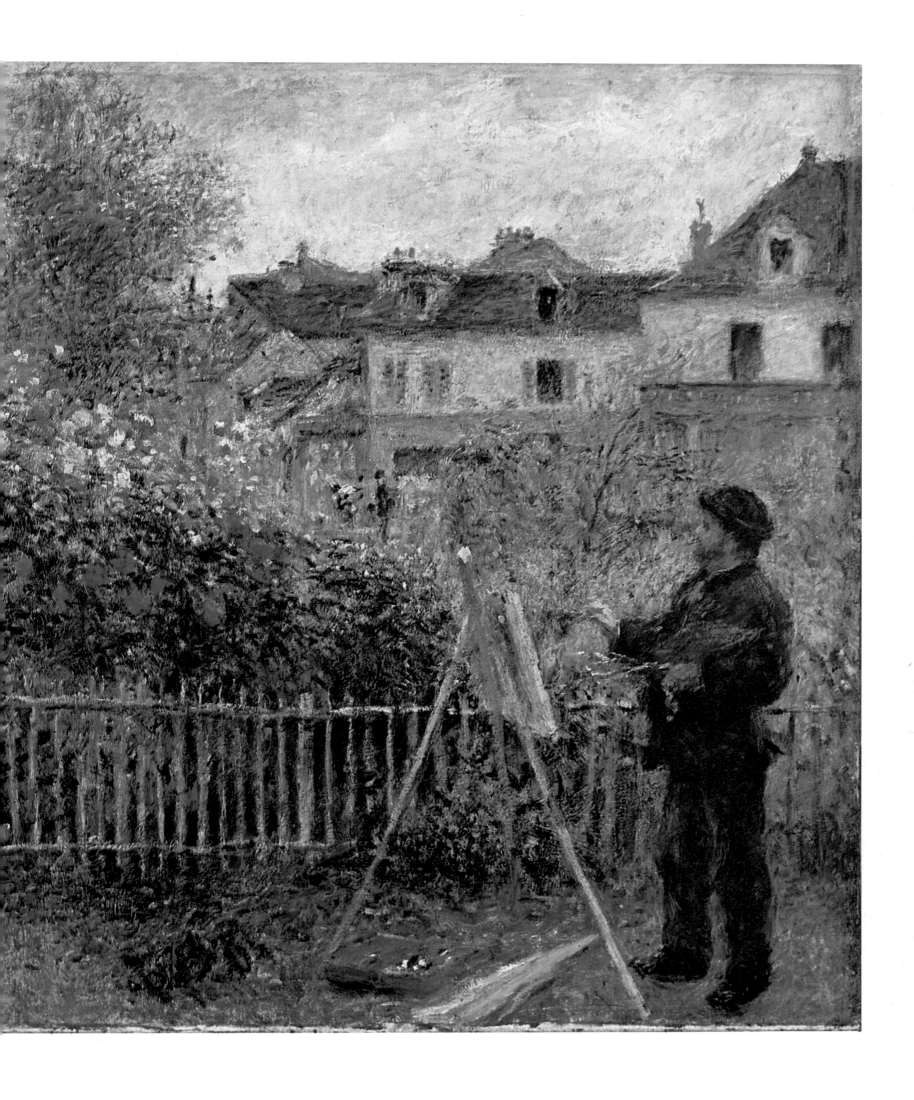

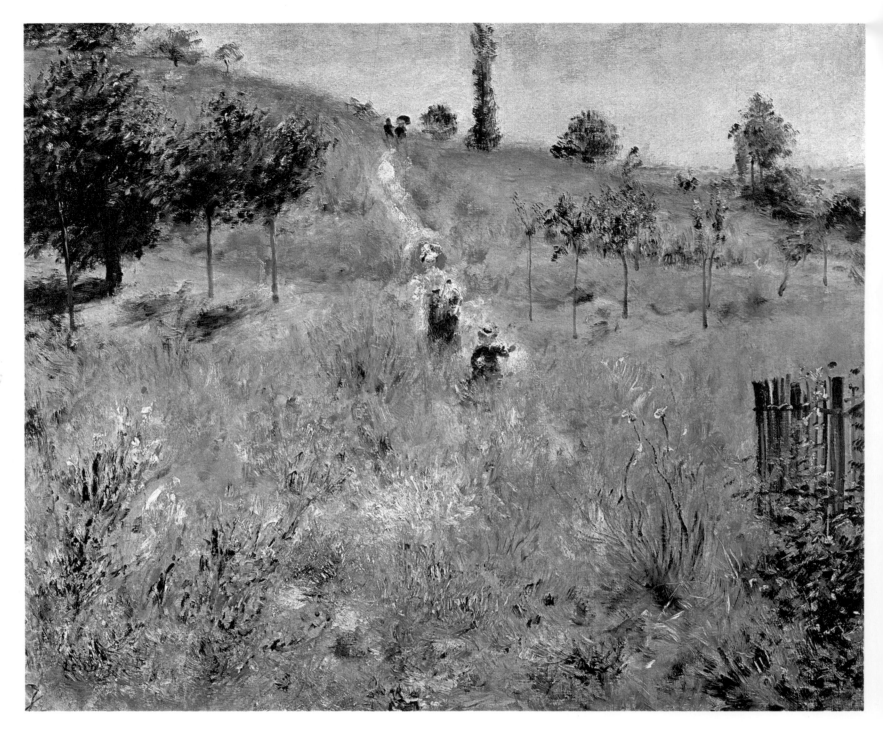

Plate 42
Path Climbing Through Long Grass
1874
23¼ × 29 in (59 × 73 cm)
Louvre, Paris

The unity of interest that enabled Renoir
and Monet to work together in the
summers of 1873 and 1874 is illustrated in
this picture, which is very similar to Monet's
The Field of Poppies of 1873. Notice also that
Renoir is developing a theme first explored
in *The Meadow* (plate 43).

original, but he did not intend to produce iconoclastic art as the
following statement reveals: 'It is the most comical thing in the
world that I should be represented as a revolutionary, I who am
certainly the greatest old fogey amongst painters.'

Cardon was not very perceptive when he said that the
Impressionists found the Old Masters banal. *La Loge*, in its use of
black and dull silver white, is indebted to Velásquez, but Renoir
has utilised this borrowing in such a way as to reveal his
admiration for Manet's use of sharp contrasts, thus making the
borrowing more ambiguous. Yet the basic quality of this painting
is very much that which he found in Velásquez: 'Velásquez . . .
this painter who breathes the joy that the painter has in painting'.

La Loge, by its virtuosity alone, shows Renoir's joy in painting

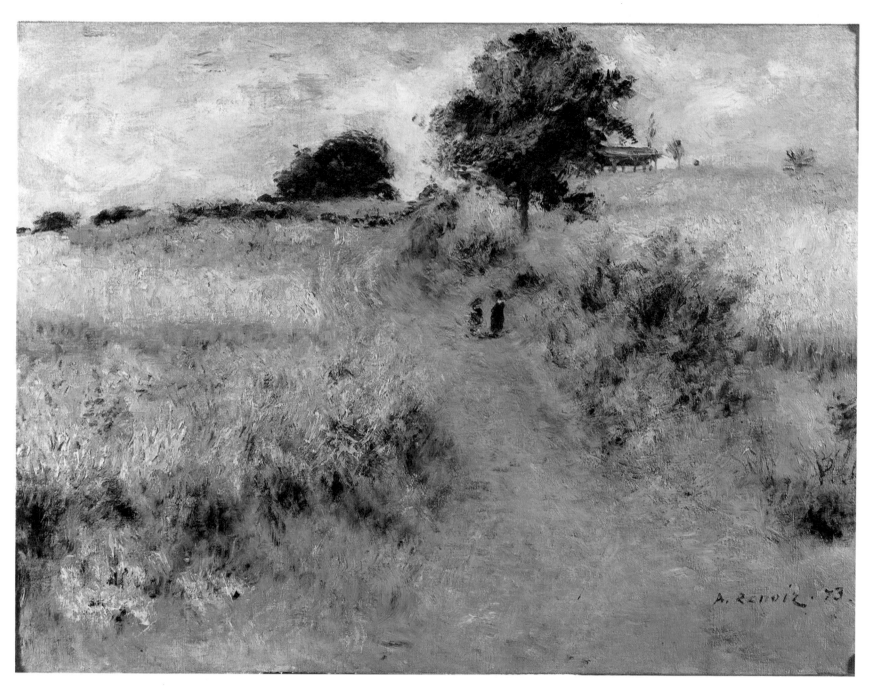

fine fabrics and delicate flesh. Several of his exhibits were of women. *The Dancer* (plate 46) shows Renoir experimenting with high-value close tones, as he had done in one of his earliest paintings, *Mlle Romaine Lascaux*, and it illustrates the difference in style between some of his portraits and his landscapes at this time. As always Renoir regulates the massing of his painting by varying the intensity of brushstrokes, but this is now softer and the contrasts are toned down.

In the summer he returned to the river and frequently visited the Monets at Argenteuil. This final summer with the Monets was a happy one. As a result of the exhibition Père Martin, the picture dealer, had given him 425 francs for *La Loge* and he had received a commission to make a portrait of the wife of a

Plate 43
The Meadow
1873
$18\frac{1}{2} \times 24$ in (47×61 cm)
Collection of Peter Nathan, Zurich

The controlled use of picture space exercised by Renoir is further emphasised by his varied use of brushstroke. By their autonomous and diverse plastic value, from the flat, semi-transparent strokes representing the clouds to the thickly massed impasto of the yellow in the meadows, the brushstrokes create a pictorial tension and surface harmony that is independant of, although reliant upon, the subject. Notice Renoir's increased use of yellow in the landscapes of this period.

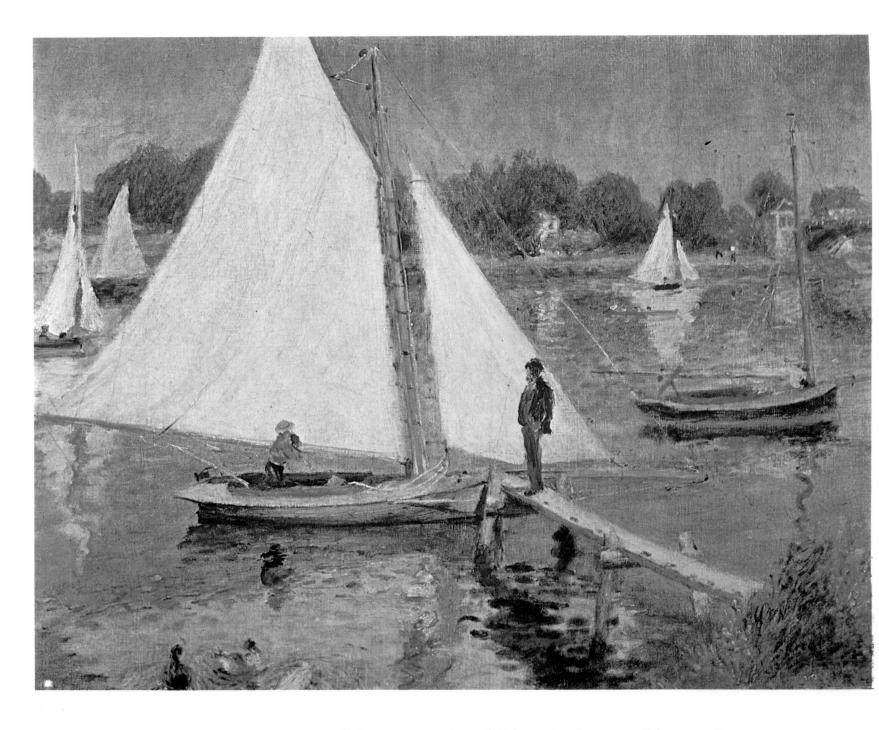

Plate 44
Sailboats at Argenteuil
1875
$19\frac{3}{4} \times 23\frac{1}{2}$ in (50 × 60 cm)
Portland Art Museum, Portland, Oregon

Renoir has used the effects of brilliant sunlight to create high-value contrasts. There are hardly any shadows in the picture, the brilliance of the light bleaching the colour. To achieve this effect Renoir used dry pigment patchily applied over unprimed canvas.

well-known music publisher. At Argenteuil he met Gustave Caillebotte, a marine engineer and amateur painter, who was rich enough to give practical help to the Impressionists. They became very close friends and spent a great deal of time sailing on the river. Their love of boats as subjects is evident in many of their works, and Renoir's *Regatta at Argenteuil* (plate 47) indicates that his outdoor painting style was beginning to change. He uses longer and more agitated brushstrokes to such an extent that they begin to dissolve the forms. The Monets, who had been so poor at the beginning of the year that they were evicted from their old cottage for defaulting on the rent, were now living in a new home that had been procured for them by Manet, who was spending the summer at Petit Genevilliers just across the river from Argenteuil.

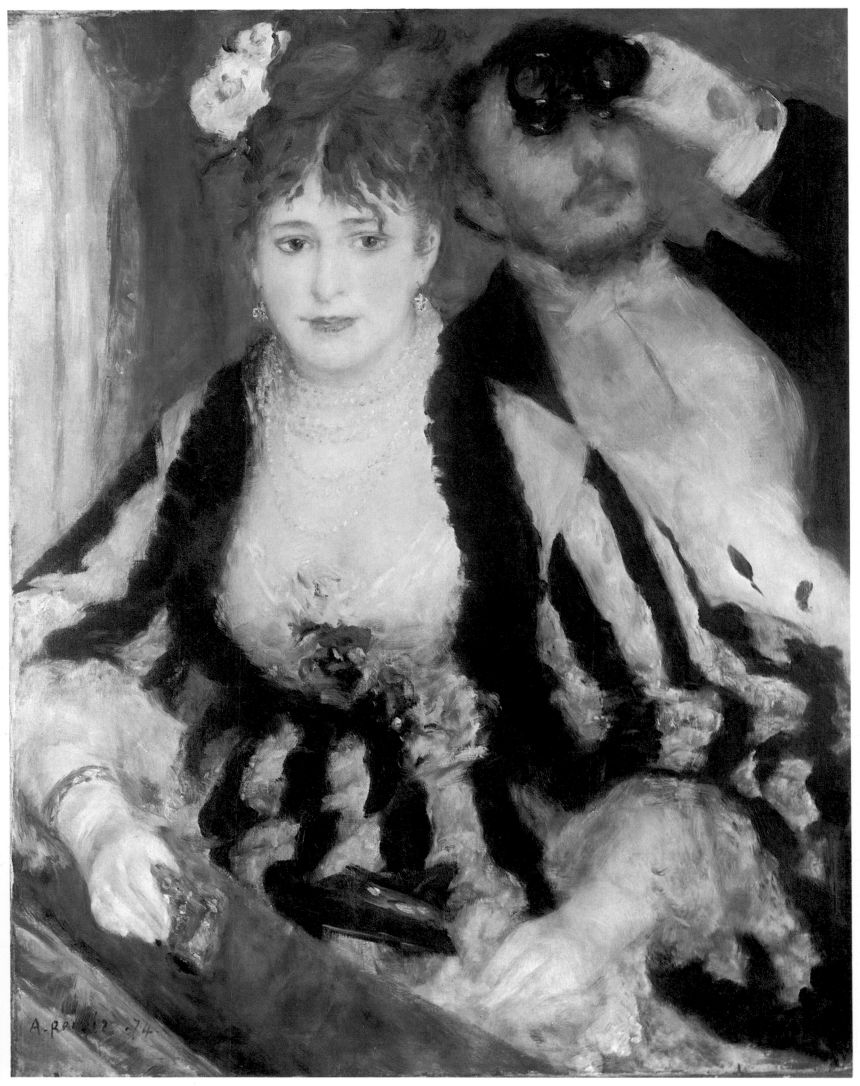

Plate 45 *see page 66*

Plate 45
La Loge
1874
31½ × 25 in (80 × 63 cm)
Courtauld Institute Galleries, London

Renoir's brother Edmond and Nini, one of
his favourite models, posed for this painting.
The variation in paint textures representing
different surface and light qualities
demonstrates Renoir's tremendous range of
technique.

Plate 46
The Dancer
1874
25¾ × 36¾ in (65 × 93 cm)
National Gallery of Art, Washington D.C.
(Widener Collection)

The pose of this figure shows that Renoir
had taken Manet as his model, as it is very
similar to that used in *Lola de Valence*.
Dancers are the subject of both paintings.

He often visited Monet and Renoir and as a result began to adopt a brighter palette and appreciate the merits of outdoor painting.

When he returned to Paris Renoir found himself involved with the aftermath of the exhibition – it had made a loss and he was put in charge of the liquidation committee. The total liabilities were 3,713 francs, but sales and entrance fees had only amounted to 279 francs, thus every member of the Society owed 185.50 francs. To offset their losses Renoir suggested they hold an auction of their work. This took place on 24th March 1875 at the Hôtel Drouot. Renoir, Monet, Sisley and Berthe Morisot put 73 works up for auction; the results were disastrous. Many of the paintings were sold for less than the reserve price and the artists had to re-purchase them through Durand-Ruel. The sale turned into a riot when students from the Ecole des Beaux Arts tried to shout down the bidders. The average price for Renoir canvases was 150 francs. The group were derided as incompetents, which, if they were judged by the standard of 'finish' required for the Salon, they were. Thus critics like Albert Wolff, writing in *Le Figaro*, attacked them in condescending terms: 'The impression left on me by the Impressionists is of a cat walking on the keyboard of a piano or of a monkey playing with a box of paints.'

What sales Renoir did make turned out to be favourable in terms of future patronage, if not for immediate financial support. The publisher Georges Charpentier bought his *Pêcheur à la Ligne* (plate 48) for 180 francs, and Renoir was gradually introduced to his literary friends at the salons held by his wife. Charpentier first met Renoir through M. Clapisson who, at the time of the Drouot sale, had commissioned the painter to do a portrait of his wife and children, known as *La Promenade*. This in itself was not extraordinary as Renoir was slowly beginning to pick up more portrait commissions, but his fee was nearly ten times that of the average price his pictures fetched at the auction. Renoir's natural elegance of style and subtle perception of character made him a splendid portraitist for clients who wanted a picture that did not conform to academic precepts. His fee for the Clapisson portrait was 1,200 francs, and this sudden improvement in his circumstances enabled Renoir to rent a second studio in Montmartre on the Rue Cortot, which he occupied intermittently between April 1875 and October 1876. It was from here that he was to paint some of his most famous pictures, including *The Swing* and *Le Moulin de la Galette*.

At the Drouot sale Renoir first met Victor Chocquet, a customs official with a passion for art. Renoir described their meeting to Vollard in the following terms: 'Choquet had wandered into the

Hôtel Drouot while our pictures were going up for auction. He was kind enough to find qualities in my work that reminded him of Delacroix, his God. Writing to me the evening after the sale, he praised my painting to the skies, and asked if I would consent to make a portrait of Mme Chocquet. I accepted at once. As you know I don't often turn down portrait commissions. If you have seen the portrait, Vollard, you must have noticed the copy of a Delacroix in the upper part of the picture. This was a work from Chocquet's own collection. He asked me to include this in the portrait. "I want to have you together, you and Delacroix," he said to me.'

The *Portrait of Mme Chocquet* (plate 49) was the first of three Renoir did for Chocquet in 1875; when he died Chocquet had eleven Renoirs in his collection. They became good friends and following the custom of all the Impressionists Renoir introduced the new patron to the other members of the group, as a result of

Plate 47
Regatta at Argenteuil
1874
12¼ × 18 in (31 × 45 cm)
National Gallery of Art, Washington D.C.
(Ailsa Mellon Bruce Collection)

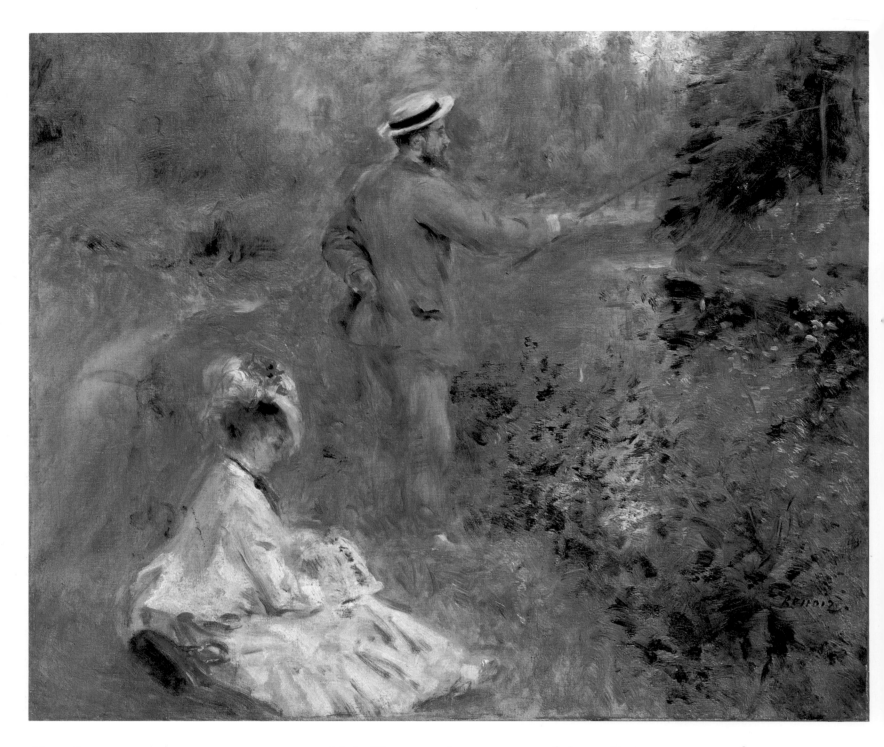

Plate 48
Pêcheur à la Ligne
about 1874
21¼ × 25¾ in (54 × 65 cm)
Private collection, England

This is painted in washes of pigment on fine-grained canvas. Renoir has created the illusion of using a varied palette when, in fact, the dominant colour is a soft pastel shade of green. He uses the areas of unpainted canvas as positive elements in the composition.

which Chocquet became one of the earliest supporters of Cézanne's work. In the first portrait Renoir did of his new admirer (plate 50) the sketch hanging on the wall is by Delacroix. Chocquet's understanding of the affinity between Renoir and Delacroix, given graphic form in this picture, was most perceptive because it was in 1875 that Renoir renewed his study of the master, having been commissioned to make a copy of *The Jewish Wedding in Morocco* in the Louvre. Whilst working on this commission Renoir became increasingly aware of Ingres' work, particularly the portrait of *Mme Rivière*. He saw that the two masters were not as opposed to each other as was commonly believed, and that within the confines of pure line Ingres expressed as intense a

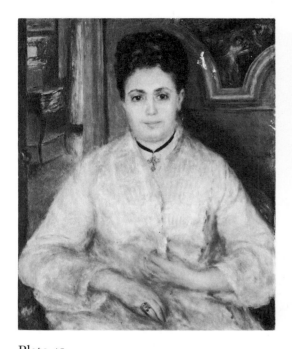

Plate 49
Portrait of Mme Chocquet
1875
$29\frac{1}{2} \times 23\frac{1}{2}$ in (75 × 60 cm)
Staatsgalerie, Stuttgart

The composition of this portrait, in which
space is both denied and emphasised by the
wall at the back of the sitter, is related to
Manet's *Portrait of Zacharie Astruc* of 1864,
which Renoir would have seen in Manet's
studio. This in turn was derived from
Titian's *Venus of Urbino*.

Plate 50
Portrait of Victor Chocquet
1875
$18 \times 14\frac{1}{4}$ in (45 × 36 cm)
Fogg Art Museum, Cambridge, Mass.
(G. L. Winthrop Bequest)

The painting on the wall behind Chocquet is
a sketch for the decorations of the Palais
Bourbon by Delacroix.

sensuality as Delacroix did in his glowing colours. The unity of
volume and form with colour and painterly style was to be the
fundamental ideal in Renoir's work from the early 1880s onwards.
He was to achieve this by means of an intense and elevated
sensuality, a feature that Chocquet had seen as common to Renoir
and Delacroix, and which the artist acknowledged as one of the
intentions of his work: 'It is the eye of the sensualist that I wish
to open.'

One of the works included in the Drouot sale was the *Young
Girl Reading in a Garden, with a Dog on her Lap* (plate 16), in which
Renoir had lessened the tonal contrasts seen in the works done at
Argenteuil, introduced a soft blue and delicate pink as unifying

Plate 51
Self-portrait
about 1875
$15\frac{1}{4} \times 12\frac{1}{2}$ in (39×32 cm)
Sterling and Francine Clark Institute,
Williamstown, Mass.

Plate 52
Nude in the Sun
1876
$31\frac{1}{2} \times 25\frac{1}{4}$ in (80×64 cm)
Louvre, Paris (Caillebotte Collection)

In the first nude for several years, Renoir
is attempting to find his own solution to the
problem of unifying the figure with the
background. The emphasis on the volumes
of the nude was to be one of the major
preoccupations of his later years.

colours, and increased the rhythmical emphasis of the picture by
using dappled sunlight, as he had done in the early works at
Fontainebleau. In the spring of 1876 Renoir took these ideas one
step further in *Nude in the Sun* (plate 52). Here he continued to use
the rhythmical but tonally even dappled light as a unifying factor
but divided the highlights into more varied strokes of pure colour.
This attempt to show the action of light on flesh prompted the
critic Albert Wolff to say of this picture, when it was shown at the
second Impressionist Exhibition in April 1876: 'Try and explain to
M. Renoir that a woman's torso is not a mass of rotting flesh,
with violet-toned green spots all over it, indicating a corpse
in the last stages of decay . . .' This indicates how wide the gap
was between the cannons of academic criticism and Impressionist
experiments with light and colour. The more even tonality

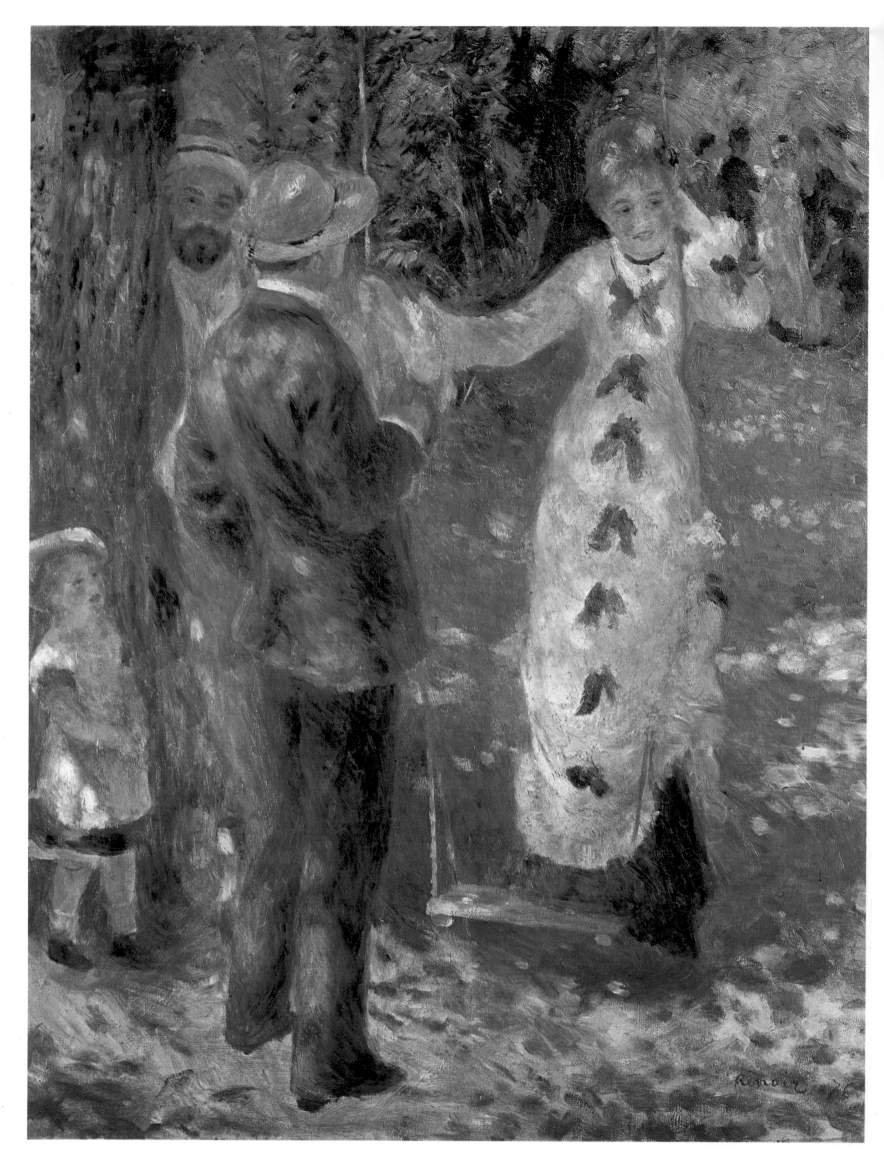

combined with a greater reliance on the optical mixture of
juxtaposed pure colours characterised many of Renoir's paintings
in the late 1870s.

In May 1876 Renoir started to paint two large open-air pictures
that were to resolve many of the problems he had been working on
in the previous months. In *The Swing* (plate 53) which he painted
in the Rue Cortot garden, he created one of his most joyful
pictures. It is a lyrical and intimate picture which, in the perfect
stillness of an instant captured for ever, fulfils Renoir's ideals of
picture-making, as he told Albert André: 'For me a painting, as we
are obliged to make easel paintings, should be an agreeable thing,
joyful and pretty, yes, pretty!'

The qualities present in *The Swing* are developed on a
monumental scale in one of Renoir's greatest works, the *Moulin de
la Galette* (plate 54). The Moulin de la Galette was an open-air
dance hall and café which had grown up around two disused
windmills in Montmartre. It was patronised by the working people
of the area, and Renoir and his friends loved to go there in the
evenings to join in the gay and unaffected atmosphere of the place.

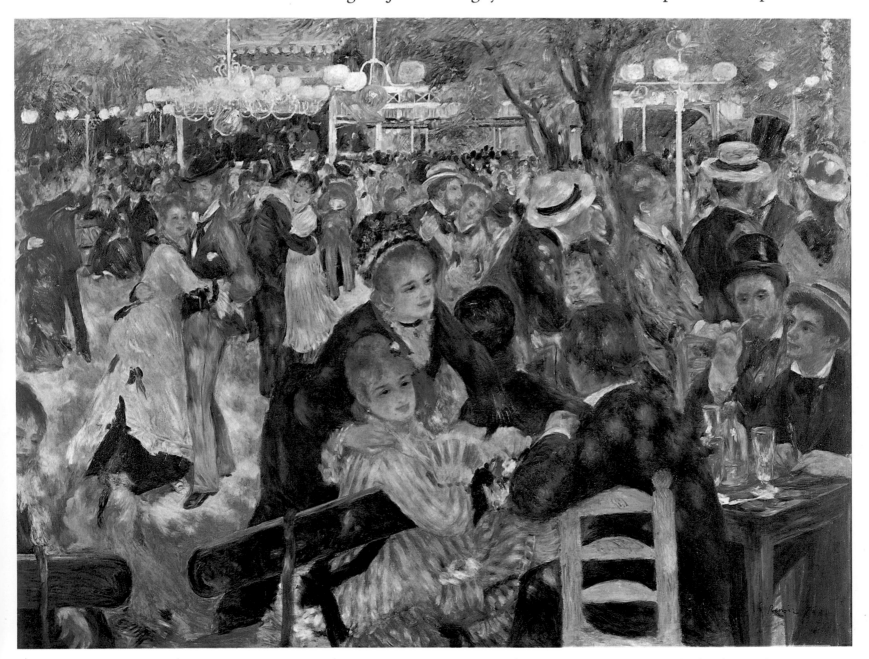

As in the *La Grenouillère* pictures Renoir almost unconsciously idealised the scene, giving it a quality of purity and timelessness that only he could create – one is completely unaware of the inevitable arguments and spilled beer. The picture was painted on the spot. The canvas had to be carried from the studio to the dance hall every evening, and Renoir told his son Jean that 'I was completely taken up with my craze for sketching from nature, like Zola driving in a carriage through the wheatfields of the Bauce before starting to write *La Terre*.'

It was this element of realism that was emphasised by his contemporaries. Georges Rivière wrote in the first edition of *L'Impressionniste*, dated 6th April 1877: 'It is a page of history, a precious and strictly accurate memento of Parisian life.' He goes on to claim that 'No-one before Renoir had thought of taking some everyday happening as the subject of so large a canvas.' This was correct, it was the biggest picture of this type of subject, but it was not the first. Its basic concept was derived from Manet's *Music in the Tuileries Gardens*, but Renoir has made his subject less refined, the Baudelairian concept of the dandy was not so attractive to him as to Manet. The dappled light acts as a unifying element on the crowded scene and the composition is articulated by the recurrent highlights on the straw boaters and the use of a frequently repeated, slightly forward-leaning pose for dancers and sitters alike. The brushwork is as varied as ever but is now somewhat thicker and drier, giving more emphasis and intrinsic plastic value to individual brushstrokes. This is evident in the yellow chairback in the foreground and in the bluish-white dress of the girl dancing behind the seated figures.

Meanwhile Renoir's career as a portraitist had been developing well, bringing him more commissions and giving him an introduction to some influential patrons. The degree of importance Renoir attached to portraiture is demonstrated by the fact that in the second Impressionist Exhibition of April 1876 he did not include any landscapes amongst the fifteen works he exhibited, and of them ten were commissioned portraits. By May of 1876 Renoir had been accepted into the Charpentier salon. The *Pêcheur à la Ligne* had impressed Mme Charpentier who now considered making Renoir her 'discovery', thereby improving her reputation as a hostess and patroness of the arts. He was given what amounted to a trial commission, *Mlle Georgette Charpentier Seated*, a portrait of Mme Charpentier's daughter, in May 1876. This came up to standard, and he was 'accepted'. In the Charpentier circle he met Zola, whom he had known for many years, Alphonse Daudet the author, the Salon painters de Nittis,

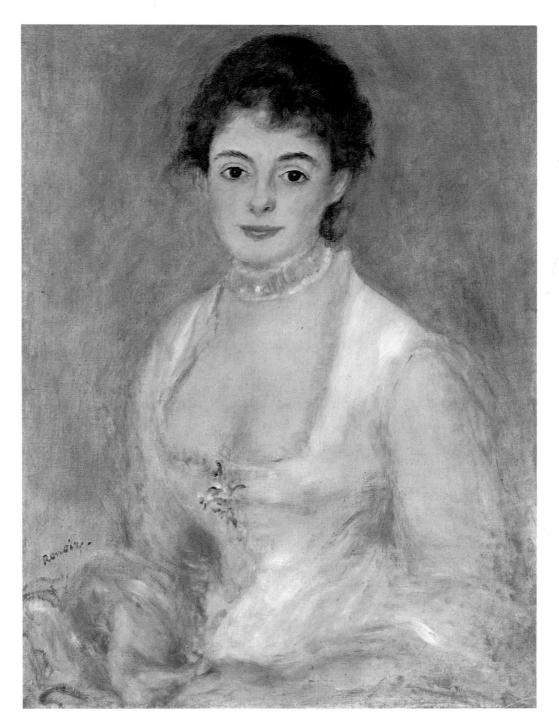

Plate 55
Portrait of Mme Henriot
1876
27 × 21 in (68 × 53 cm)
National Gallery of Art, Washington, D.C.
(Gift of the Adele R. Levy Fund, Inc.)

Mme Henriot was one of Renoir's favourite
models in the mid 1870s, and she posed for
at least three paintings. This picture, which
has been compared with the work of the
French 18th-century painter Perronneau, is
given necessary emphasis by the contrast of
the sitter's warm red hair against the delicate
flesh tints and the cool blue-white of the
dress.

Henner and Duran, the critic Edmond de Goncourt with whom he
shared a common interest in the 18th century, and Paul Bérard, a
diplomat and banker, whom he had first met through Charles
Deudon, and who became one of Renoir's most constant and
understanding patrons. He received commissions from Durand-
Ruel whose financial position had begun to improve, and the
Cahen D'Anvers, who were rich and influential. Renoir
appreciated that it was only from the rich bourgeoisie that he
would receive adequate patronage, and to a certain extent he
rather cynically exploited the market. He did become friendly with
some of his new patrons, especially the Bérards. But at the same
time he kept in touch with his old friends. He visited the Nouvelles

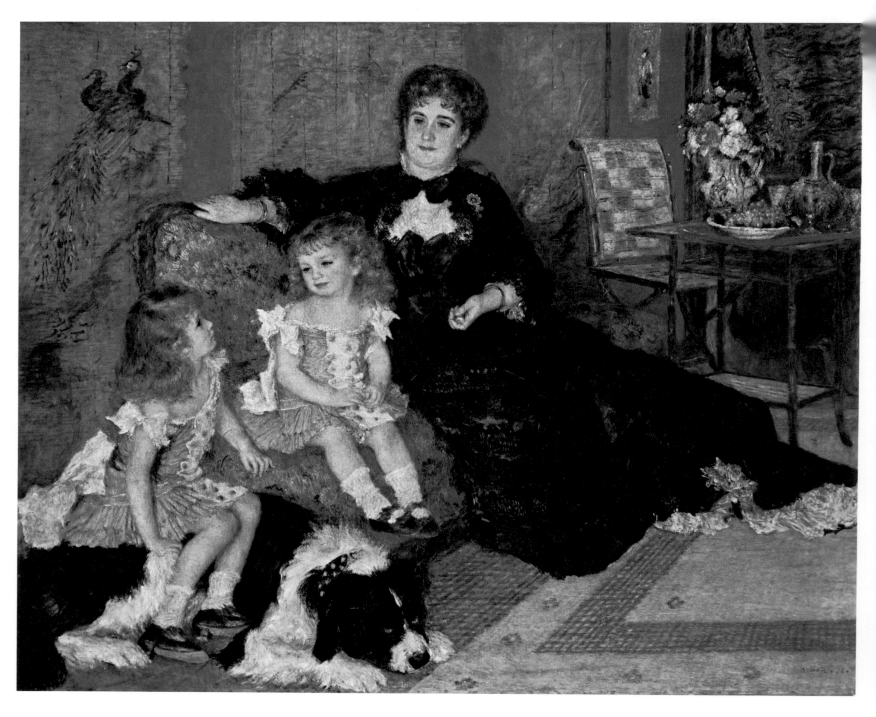

Plate 56
Mme Charpentier and her Children
1878
60½ × 74¾ in (153 × 190 cm)
Metropolitan Museum of Art, New York
(Wolfe Fund, 1907)

The formal and informal elements of this
picture are combined most successfully. The
children have an appealing innocence and
sweetness. Mme Charpentier is shown in an
elegant pose that is reminiscent of 18th-
century portraiture, but her opulent
formality reminds the viewer that she is the
wife of a 19th-century bourgeois.

Athenées frequently, where he met several of the most influential
poets of the time, some of whom later bought his paintings. They
included Catulle Mendès, Villiers de l'Isle Adam, Jean Richepin,
Charles Cros. It was at about this time that he became aware of
Mallarmé's work, as Manet had now become friendly with the
poet. In the 1880s Renoir and Mallarmé were to become close
friends.

In September 1876 Renoir spent several weeks at Alphonse
Daudet's country house at Champrosay on the edge of the Forest
of Sénart. This was an especially poignant visit for Renoir, as
Delacroix, his idol, had once lived in the area. During his stay at
Champrosay he painted the *Portrait of Mme Alphonse Daudet*,
which in its refined and elegant pose is reminiscent of 18th-century
portraiture. Stylistically it relates to the *Moulin de la Galette* in its
use of clearly defined brushstrokes of dense, slightly dry pigment.

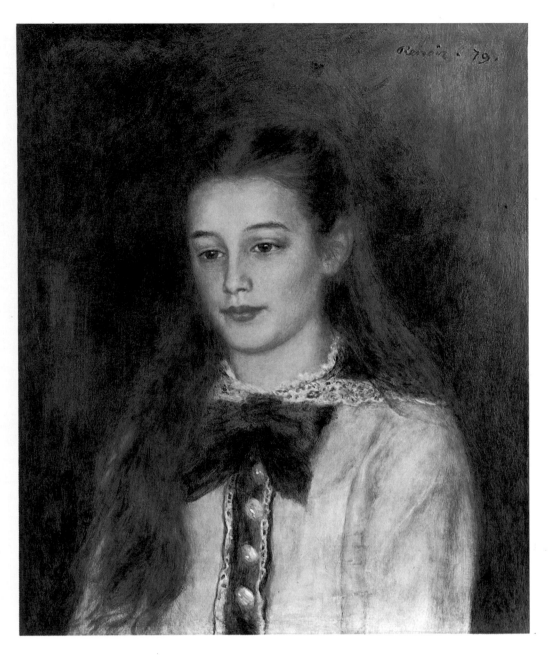

Plate 57
Portrait of Mlle Thérèse Bérard
1879
22 × 18½ in (56 × 47 cm)
Sterling and Francine Clark Art Institute,
Williamstown, Mass.

Note the exquisitely subtle characterisation
of, and Renoir's obvious interest in, the
sitter's hair. He was to become fascinated by
the decorative possibilities of long hair in
the nudes he painted in the late 1880s and
1890s (see plate 81).

Its feeling of 18th-century refinement relates it to a group of
paintings Renoir started in the latter half of 1876 and which
continued until at least 1878. One of the most exquisite of these is
Mme Henriot (plate 55), a portrait of an actress at the Comédie
Française. Renoir has returned to the smooth style of painting he
had used in the second Victor Chocquet portrait, and which he
seems to have preferred when painting in close, high-value tones.
Renoir was obviously captivated by his sitter's fragile beauty and
has complimented this by painting her in a white dress on a white
background. The painting is so delicate that she appears to
materialise from nothing, emerging from the background by
touches of the most subtle shades of blue on the dress, and pale
flesh tints around the neck. Drawing in the normal sense is reduced
to a minimum, and yet, where it is necessary around the delicate
features, it is accurate and used to great effect.

The Impressionist group as a whole was being taken more seriously, but only by a few collectors and critics, such as Duret, who wrote *Les Peintres Impressionnistes* in 1878, in which he dealt with the main artists, Monet, Sisley, Pissarro, Renoir and Morisot, individually; but even such erudite works as this did not extend their reputations or increase their fees. Thus, after organising the third Impressionist Exhibition in 1877, with his friend Caillebotte, Renoir made a determined effort to achieve recognition by submitting a large-scale formal portrait to the Salon of 1878. In the winter of 1877–78 he painted *The Cup of Chocolate* which was accepted for the Salon in the spring. This automatically excluded him from the fourth Impressionist show and caused much bitterness to be directed against him by his former colleagues. He did not exhibit at either the fifth or sixth Impressionist Exhibitions, and in 1881 he wrote to Durand-Ruel from Algeria, defending his actions of the previous years in the following terms: 'There are scarcely fifteen collectors able to appreciate a painter outside the Salon. There are eighty thousand who wouldn't buy even a nose if the painter hadn't shown it in the Salon. That's why I send two portraits every year, poor though they be. Besides I do not want to fall into the absurdity of thinking that a thing is bad or good just because of the place in which it is seen. In a word, I don't want to waste my time inveighing against the Salon . . . I beg you to plead my cause with my friends. My submission to the Salon is purely commercial.'

The Cup of Chocolate was moderately successful and this prompted the Charpentiers to commission Renoir to paint *Mme Charpentier and her Children* (plate 56) in 1878. This came at the right time for Renoir whose prices were declining at an alarming rate. In June at the Hoschedé sale, his canvases had only fetched 31, 42 and 84 francs respectively. Renoir went to a great deal of trouble over this portrait and demanded many sittings from his patroness, her son and daughter and their dog. They are shown sitting in the small Japanese drawing room of the Charpentier house; Edmond Renoir claimed that his brother did not 'compose' any of the objects in the room. The figure composition is conventionally triangular but Renoir has managed to combine a studied informality of pose with an overall feeling of dignity. His patroness saw to it that the picture was hung 'on the line' at the 1879 Salon and it was the hit of the show. At last Renoir had 'arrived', his prices went up accordingly and the other picture he had exhibited at the Salon, *Portrait of Jeanne Samary*, although not receiving the acclaim of the Charpentier picture, fetched 1,500 francs.

For a short time Renoir became very popular as a portraitist. He could write to Mme Charpentier in the autumn of 1880: 'I began one portrait this morning, I begin another tonight, and after that probably a third.'

In the summer of 1879 he was invited by Paul Bérard to stay with his family at their country house at Wargemont near Dieppe. His portraits of the Bérard family are amongst his most subtle and charming, although, as Duret relates, even with friends like the Bérards Renoir was careful not to do anything too startling on a first commission. Writing of the *Portrait of Marthe Bérard* which was done in the early spring of 1879, he says that Renoir 'cautiously kept to a scale of sober tones in order not to startle his patron. He abstained from bright colours . . . The portrait pleased the girl's parents and friends of the family who came to see it.'

At Wargemont Renoir painted a portrait of the Bérards' niece, *Mlle Thérèse Bérard* (plate 57), which shows how much more bold he had become, using a more glowing and freely Impressionist technique. During this summer he painted some of his most joyful works, either with the Bérards at Wargemont, or with Caillebotte and his friends on the Seine at Chatou. In these his brushwork was free and varied, sometimes employing glazes and at others using more sculptural masses of pigment. His colours are relatively even in tone; soft pinks and delicate powdery blues are used to achieve the effect of colour seen through an intense heat haze. This is seen in the *Festival of Pan*, a decorative work executed for the Bérards (plate 58) which is almost magical in its evocation of youth and timelessness.

Plate 58
The Festival of Pan
1879
$26\frac{1}{4} \times 30\frac{1}{4}$ in (67×77 cm)
Present whereabouts unknown

This is the first allegorical subject that Renoir tackled, but it is more a product of his own vision than of anything from Antiquity. In the last years of his life Renoir turned to more Classically inspired allegories. The figure in the foreground also appears in a series of sketches entitled *The Four Seasons*, executed for the Charpentiers.

79

Renoir
and Classicism

Renoir went back to his old haunts on the Seine between Chatou and Bougival in the summers of 1879, 1880, and 1881. The joy he found there with his old friends Monet, Caillebotte, and Berthe Morisot is reflected in this painting. The girl sitting in the left foreground of the picture, holding a dog, is Aline Charigot, who was to become his wife. The figure sitting on the reversed chair is Caillebotte. Amongst the other sitters are Angèle, drinking; Mme Henriot, leaning on the rail; Ephrussi, in the top hat; Lestringuez and Paul Lhote. The picture was shown at the seventh Impressionist Exhibition in 1882.

Chocquet bought this portrait. Renoir made a lithograph of it in 1902.

Renoir described the crisis that developed in his work in the mid 1880s in the following words: 'At about 1883 a break came in my work. I had reached the end of Impressionism and came to the conclusion that I did not know how to paint or draw. In a word, I had reached an impasse.'

The loss of confidence in Impressionist style and method that emerged in the early 1880s was not confined to Renoir alone. Monet turned towards a more synthetic style of open-air painting in which objects became vibrating masses of light, and Pissarro experimented with the Neo-Impressionism being developed by the younger, more classically orientated generation led by Seurat and Signac.

The negative elements in the re-evaluation of his style arose from a profound dissatisfaction with the direction his work was taking, as opposed to what he felt to be its true aims. He realised that the society portraits which were making his name also revealed what he saw as a weakness: his facility. The ease with which he could paint made him fear that his style would degenerate into the slickness of the more chic portraitists of the day. His dissatisfaction with the commercial elements in his art extended to the cliquish and reactionary attitude of the Salon which was more of a market-place than a vehicle for the display of the finest art. He wrote to the Minister of Fine Arts with plans for a fairer Salon, and had the letter published in *La Chronique des Tribunaux* of 2nd May 1880. This had no effect other than to bring about a cooling of his relationship with Zola, who was more concerned with his own ideas of naturalism and the contemporary subject than he was with Renoir's ideal of an art that would eliminate the particular. Throughout the 1880s Renoir's popularity declined due to his intensely personal search for style, and when he ceased to exhibit at the Salon in 1883 he was faced with financial as well as artistic problems.

His rejection of Impressionism grew from an increased concern with line and the purity of form and composition, all important elements of Classicism. He saw exclusively open-air painting as

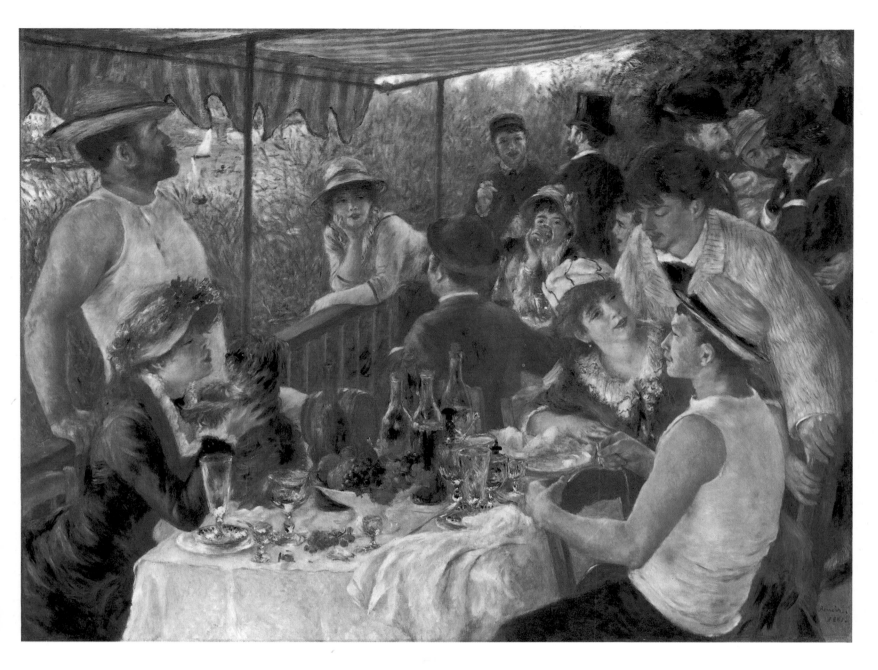

harmful to the unificatory virtues of composition. He explained
this to Vollard: 'There is a greater variety of light outdoors than
in the studio . . . because of this, light plays far too important a
part, you have no time to work out the composition.' And
whereas he found the variety of dappled light to be a unifying
element in works like the *Moulin de la Galette*, it did not satisfy his
current need to define form and articulate the individual elements
of a composition. Thus in *Le Déjeuner des Canotiers* ('The Luncheon
of the Boating Party', plate 59) of 1881, he attempts to unify and
define the composition. To this end he has placed the group in an
even light created by the canvas awning, given a firmer outline to
the figures, and limited his range of colours. The background,
which is painted in the soft and diaphanous style of the late 1870s,
also has an even, high tonality created by the mass of greenish-blue
foliage.

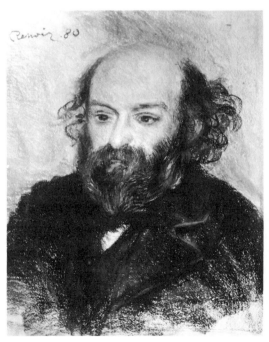

Plate 61
Dancing in the Country
1883
70 × 35½ in (178 × 90 cm)
Durand-Ruel & Cie, Paris

The models are Aline, his future wife, and
Lhote.

Plate 62
**Les Parapluies
(The Umbrellas)**
1884
71 × 45¼ in (180 × 115 cm)
National Gallery, London

This picture clearly illustrates the break that
occurred in Renoir's style in the early
1880s. The figures on the right were
executed considerably earlier than the rest
of the painting, and still retain the softness
of his Impressionist style. The emphasis on
form and clear outline in the remainder of
the picture is typical of his fully developed
manière aigre.

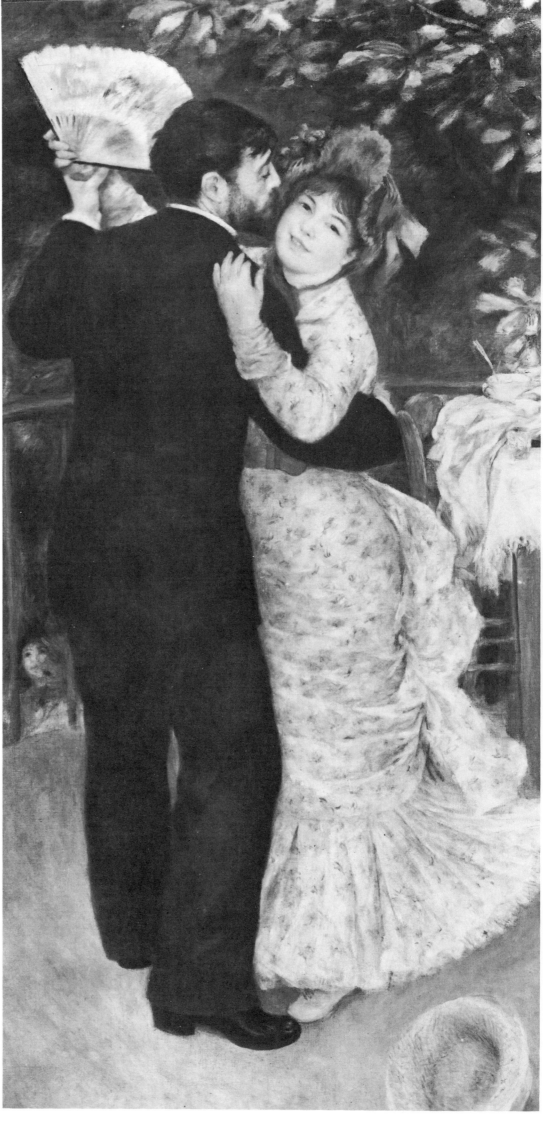

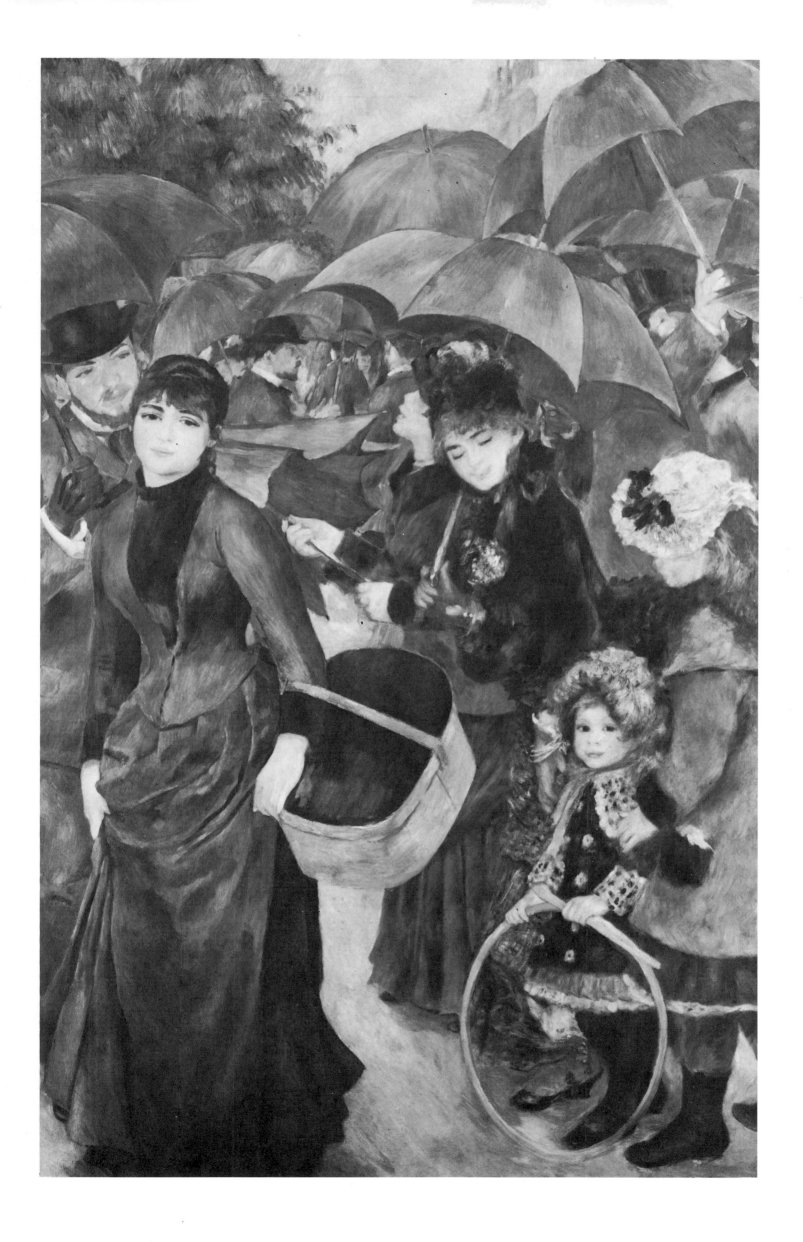

Plate 63
Mosque at Algiers
1882
19¼ × 23¼ in (49 × 59 cm)
Collection of Stavros S. Niarchos

Renoir's growing dislike of the emphasis on form-dissolving light, which results from an exclusive reliance on outdoor painting, is linked with his increasing respect for the work of Corot. He admired the master's ability to 'correct nature' by working his compositions up in his studio from sketches he had made in the open air. He quoted the advice Corot had once given him to Vollard: '. . . you can never be sure of what you are doing out of doors. Always paint over in the studio.' He believed that this method gave Corot's work the power to interpret nature 'with a realism no Impressionist painter has been able to match'. Evidence of Renoir's growing interest in the master's work is provided by some of his reactions to Italy, which he visited in the autumn of 1881. Upon discovering the frescoes of Pompeii, and Greco-Roman art in the Naples Museum, he immediately

associated his re-discovery of Classicism with Corot. 'It was Corot himself, the whole of his art, that I found again in the museum of Naples.' The re-evaluation of the Classical tradition led Renoir to state that: 'With Nature one is bound to become isolated, I want to stay in the ranks.' Renoir saw himself as part of the tradition that led back through Corot, Poussin and the Renaissance to Greece and Rome.

The increasing emphasis on drawing in Renoir's work is perhaps the fundamental element in the *manière aigre*. (The term *manière aigre* [sour manner] is used to describe the phase in Renoir's art when his concern with line and form caused him to abandon his more lush, spontaneous and painterly manner.) He had begun to attach importance to preliminary sketches in the 1870s, those for *The Swing* being an example. This was further encouraged by the drawings he was commissioned to do for Charpentier's magazine, *La Vie Moderne*, in 1879. The outcome of the new linear quality in his work was that he did many sketches in lead pencil and sanguine throughout the 1880s. He aimed for a density of mass and precision of contour, and in the series of pastel portraits that he started in 1880 the emergence of these qualities can be seen. In the *Portrait of Paul Cézanne* (plate 60) Renoir achieved a sense of solidity and volume by the use of a dense pastel technique and a subtly undulating outline. The visit to Italy in 1881 reinforced his belief in the importance of drawing as a method of defining mass; he was very impressed by Raphael's frescoes in the Farnesina where the figures are painted with a very clear and simple outline to define the gently undulating masses of flesh. In the winter of

Plate 64
The Gondola in Venice
1881
$21\frac{1}{4} \times 25\frac{3}{4}$ in (54 × 65 cm)
Collection of Mrs Janice Levin Friedman, New York

Plate 65
Blonde Bather
1881
$32 \times 25\frac{3}{4}$ in (81×65 cm)
Sterling and Francine Clark Art Institute,
Williamstown, Mass.

Renoir has made no attempt to unify the
lighting of the figure with the atmosphere
of the background. The bather is one of the
earliest of the broad-hipped, almond-eyed
type that he was to prefer in his later work.

1882–83 Durand-Ruel commissioned Renoir to paint two
decorative panels, *Dancing in the Country* (plate 61) and *Dancing in
the Town*. In these it becomes obvious that Renoir's painting style
is changing under the influence of his emphasis on drawing and
form. The figures are more solid and the outlines are clearly
emphasised in an even light. In the same year he read Cennino
Cennini's *Treatise on Painting*, a book on technique published in the
early Renaissance. This further emphasised the importance of
drawing and clear monumental outline in fresco technique. In *Les
Parapluies* (plate 62) the umbrellas have the clarity and conciseness
of a cartoon. When this is compared with the work done before
1879 it becomes clear why Renoir thought that there was a break
in his work in 1883; the emphasis has completely changed from
the painterly to the linear, light has been abandoned for form and
monumentality.

In February and March of 1881 Renoir made his first visit to
Algeria, with his friends Lhote, Lestringuez and Cordey. Although
it rained a great deal while he was there, he saw enough of the
Algerian sunlight to be impressed by its intensity. It emphasised
the value of white in outdoor painting and increased his awareness
of warm colours, especially red and yellow. It is noticeable that
in the *Déjeuner des Canotiers*, painted after his return, Renoir has
used white extensively to convey the impression of the muted
and cool light under the canopy. Renoir was forced to return to
Algeria in the spring of 1882. Whilst staying with Cézanne at
L'Estaque, on his way back from Italy, he had caught pneumonia
as a result of being soaked in a rainstorm. He returned to Algiers to
convalesce. This removed him from the activity surrounding the
seventh Impressionist Exhibition organised by Durand-Ruel, who
badgered him into exhibiting with the group again, although for
the last time. The renewed contact with Africa strengthened the
impressions made on the first visit, and in *Mosque at Algiers* (plate
63) the brilliant whites and contrasting blue shadows are the
product of an intense and unvarying light. It is this quality of even
light that had the most lasting effect on his work.

After spending the summer with the Bérards at Wargemont in
1881, Renoir went to Italy. This sudden urge to travel is indicative,
allowing for the poverty of the early years, of the dissatisfaction he
felt with his work at this time; he had to see new things to
stimulate his creativity, which he felt was stagnating. His first stop
was Venice, where the golden light beguiled him into a last burst
of Impressionism. In *The Gondola in Venice* (plate 64) any idea of
structure or form is almost completely obliterated by the mist of
brushstrokes that Renoir has used to capture the elusive quality

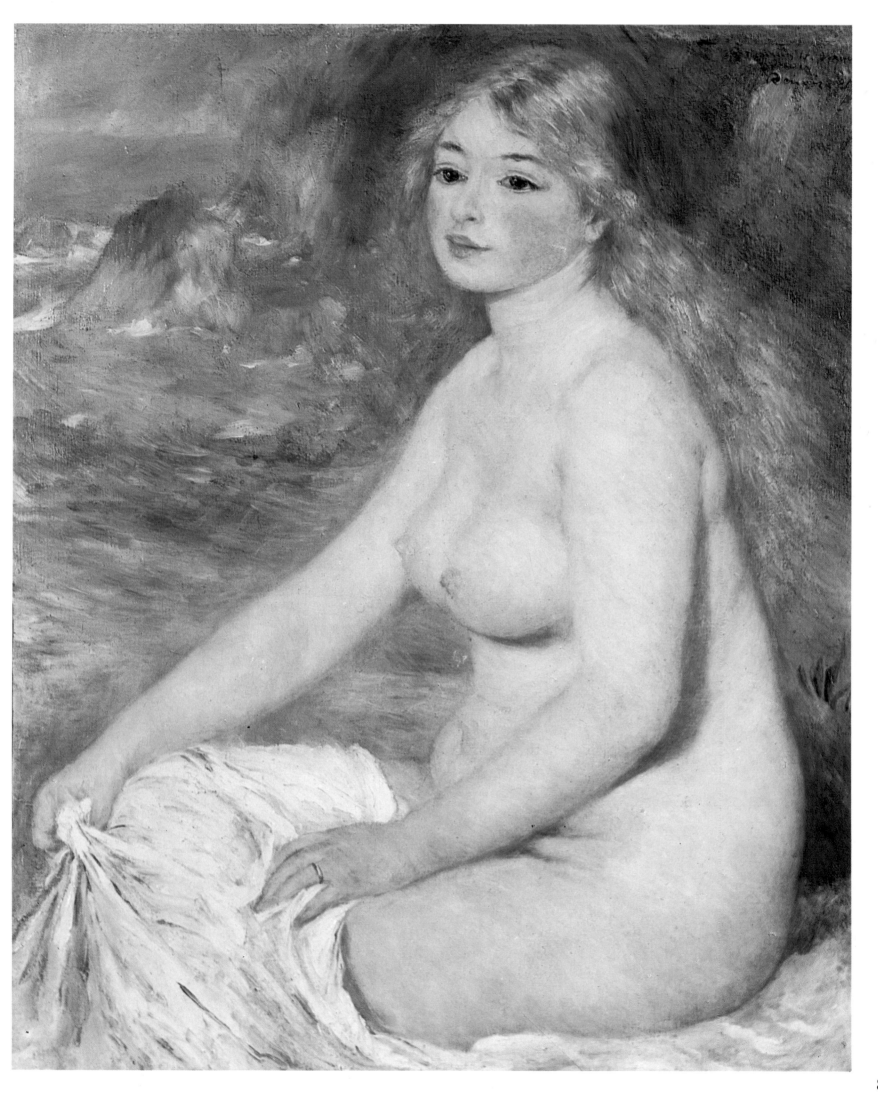

Plate 66
Fruit of the Midi
1882
20 × 27 in (51 × 68 cm)
Art Institute of Chicago (Reyerson
Collection)

This picture, although influenced by
Cézanne, has an air of 18th-century delicacy
about it, seen in the sparkling pattern of
highlights on the fruit.

of Venetian light. Apart from a view of the Bay of Naples done
later in the year, Renoir was never to return to such a formless
rendering of the vapours of light. In Rome, his next stopping-
point, he did very little work, and spent most of his time in picture
galleries and churches studying the Old Masters. In a letter to
Durand-Ruel he reveals the malaise he found himself in when he
saw the work of Raphael: 'I am like a schoolboy. The blank page
must be filled with fine script, but oh – a blot. I'm still making
blots and I'm forty! I have seen the Raphaels in Rome. They are
very beautiful and I ought to have seen them long ago. They are
full of knowledge and wisdom. He is not like me, he does not
seek the impossible. But how beautiful he is.'

It had been the wish to study Raphael that prompted him to go
to Italy in the first place, and in his work he saw an ideal of grace
and subtlety which combined sensual earthiness with a timeless
monumentality. He fought to keep the integrity of his artistic
personality whilst learning from the Old Masters. As he told his
son Jean: 'The difficulty is to study the great masters without
copying them. And you must copy them to understand them.'

He found Rome overpowering: tired of the works of
Michelangelo and Bernini he was glad to leave for Naples in
November. Much of his time was spent in the museum looking at
statues and casts, but he did visit Pompeii several times where he
was fascinated by the frescoes. The concentration on form and

volume in the painting of the figures, to the exclusion of background and considerations of lighting, revealed an ideal economy of means and discipline to Renoir, which was to be at the back of his mind in many of the nudes he painted in the following years. In Naples he painted a *Bather* (plate 65) which combines elements of what he had learned in Italy with remnants of his old style. The outline of the girl's body is firmer and there is a greater emphasis on the purity of shapes and volumes than in the nudes he painted in the 1870s. This is offset against a freely painted background of cliffs and water. Renoir painted Wagner's portrait at Palermo, when the composer was putting the finishing touches to the music-drama *Parsifal*. The resulting painting may have a certain amount of curiosity value, but it does not number among Renoir's best.

On his return from Italy, Renoir met Cézanne at Marseilles on 23rd January 1882 and he stayed with him during the early months of the year at L'Estaque. They had known each other on close

Plate 67
Children in the Afternoon at Wargemont
1884
$51\frac{1}{4} \times 67$ in (130×170 cm)
Nationalgalerie, Berlin
The Bérards were one of the few of Renoir's patrons who supported him through the critical period of the 1880s. This painting shows Paul Bérard's three daughters: Marguerite, Lucie, and Marthe.

terms since the spring of 1880, when Cézanne had been living in the Paris suburb of Plaisance, but they did not work together until the following year when they painted in the south. Although Renoir's landscapes at this time are filled with the brilliant light of the Midi, they do not show any of the structural quality present in Cézanne's work at this time. His concentration on the even, generalising light is borne out in a letter to Mme Charpentier: '... I no longer worry about small details which tend to extinguish the effect of sunlight instead of enhancing it.' In the *Fruit of the Midi* (plate 66) of 1882 Renoir has assimilated ideas from Cézanne's still-lifes. The formality of the arrangement is Cézanne's, and likewise the manner of painting some of the fruit, especially the peppers; but Renoir has added his feeling for luxuriance in the rich variety of the fruit and the decorative treatment of their arrangement. In more general terms, Cézanne's will to carry on painting against all odds must have inspired Renoir in this difficult time, especially when he visited him in December 1883 after having been to Genoa with Monet; it was at this time that Renoir was becoming fully aware of the bankruptcy of his previous style. Both shared a similar outlook on art, and Cézanne could have been speaking for Renoir when he said: '... one does not substitute oneself for the past, one merely adds a new link to the chain'.

The feeling of continuity with the past was fundamentally important to Renoir in this critical period. Cézanne gave direction and support to Renoir's own ideas both in general terms and in elements of technique. Thus in *Children in the Afternoon at Wargemont* of 1884 (plate 67), Renoir has not only used a complex pictorial organisation that depends on the interrelationship of planes and limited effects of perspective created by the table and chairs, but also a more regular and even pattern of brushwork extending across several motifs giving an overall unity to a variety of forms. This is a feature that is seen in Cézanne's work and has been described by Barnes as 'the techniques of brushstrokes organised in patches, which function as planes'. In other works like the *Return from the Fields* of 1886 Renoir uses Cézanne's system of modelling and drawing by hatching with separated brushstrokes in closely related tones. Renoir visited Cézanne at his home, Jas de Bouffon, in January and February of 1888 and after that they went to Martigues and Marseilles together, but later in the year when Renoir payed a second visit to Aix they had an argument and their friendship ended.

Towards the end of 1884 Renoir started on *Les Grandes Baigneuses* (plate 68) which preoccupied him for the next three

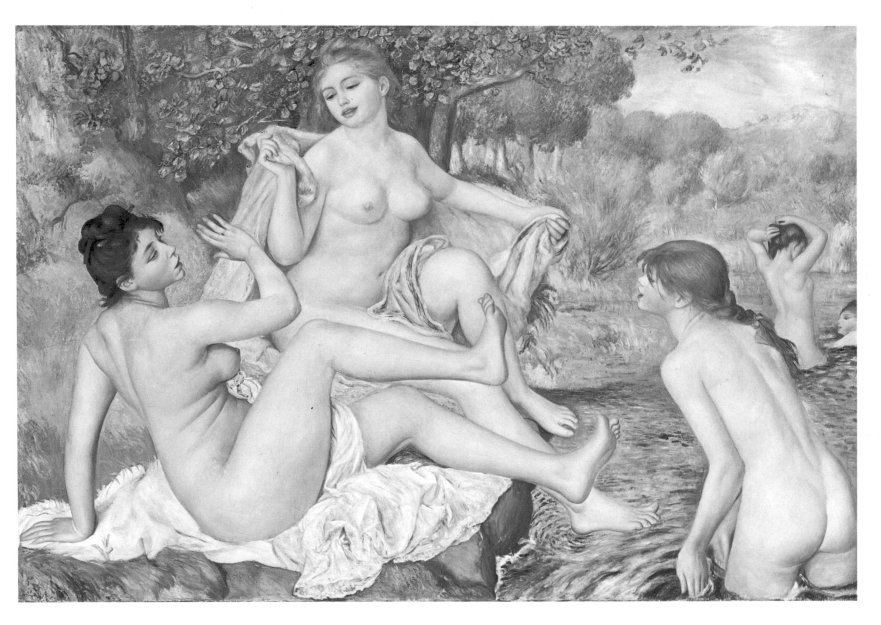

Plate 68
Les Grandes Baigneuses
1884–87
45½ × 67 in (115 × 170 cm)
Philadelphia Museum of Art (Mr and Mrs
Carroll S. Tyson Collection)

Renoir has taken the theme of bathers and
created a personal and timeless world. The
pastel greens and blues of the landscape
background reveal the influence of southern
light on his painting at this time.

years. It may be considered as the most extreme point of the
manière aigre. Taking the consequences of the stylistic developments
of the previous five years into account, it also signified a new phase
in the development of this manner. The years in which Renoir
worked on the painting were unsettled and he travelled
compulsively in 1885 and 1886, unable to settle in any one place.
Only at the village of La Roche Guyon on the Seine was he able to
find any peace; it was further away from Paris than his old haunts
and thus quieter, and it was also close to his friend Monet who was
living at Giverny.

A sentence from a letter he wrote to Durand-Ruel in
September 1885 shows that Renoir thought he had moved into a
different stage with the *Grandes Baigneuses* and reveals one of its
influences: 'I have recovered, never to leave it, the old painting,
sweet and light . . . it's nothing new but follows the 18th century.'
The gaiety of this work, as Renoir states, owes a great deal to the
18th century, but the monumentality of the figures is very different

from the lightness of Boucher's nudes. His source for the treatment of the theme and the pose of one of the main figures is a 17th-century bas relief on the ornamental pond of the Allée des Marmousets in the gardens at Versailles by François Girardon, entitled *Nymphs Bathing* (plate 69). The other major source of inspiration for *Les Grandes Baigneuses* was Ingres. Renoir did not borrow from particular models in his work, although he is known to have admired the *Grande Odalisque*, *La Source*, and the portrait of *Mme de Senons* amongst others. He used the principles he found in the master's works as guides to the perfection of his own ideal of figure painting. Thus he said to Vollard that it was '. . . eternally difficult to have brilliance and grace, without skinniness, like Ingres'. Renoir was aiming for a balance between sensuality and order, and he found it in Ingres' pure outlines, and the beautifully modelled volumes of flesh that they enclosed. He did many preliminary sketches for the *Grandes Baigneuses*, usually in a large format to avoid the process of squaring up, as he felt that small sketches did not always work on an increased scale. In the *Three Bathers* (plate 70) it is clear how Renoir has managed to combine an almost sculptural sense of volume with an exquisite sureness and purity of outline. In the finished work he has transformed the tentative ideas expressed in the sketches into a personal ideal of monumentality, purity, joy and sensuality. But something is lacking. In spite of the poses expressing gay abandon the figures appear constricted, as if the tightness of the outline and finesse of

Plate 70
Three Bathers
about 1885
pencil
42½ × 64 in (108 × 162 cm)
Louvre, Paris

In this sketch, Renoir's method of drawing
large-scale variants of ensembles and
individual figures can be seen. The poses
shown here did not completely satisfy him,
and if the finished painting is compared
with this sketch it is possible to see how
subtle was his feeling for form and balance.

painting have frozen all movement. This is especially apparent in
the recoiling figure which looks more like a toppling statue than a
moving human being. The gap between method and its ability to
express the artist's intention exposes the failing in the *manière
aigre*, for the frigidity of line had, to a certain extent, constricted
Renoir's natural sensuality. He had to find another way of
expressing form and volume in the figure and of uniting it with its
surroundings, but this would involve a gradual softening of his
style and a return to his innate painterly manner.

In 1885 Renoir's first son Pierre was born (he had married Aline
Charigot in the summer of 1882), and in the following year he
painted his wife and child in a picture called *Maternité* (*Mme
Renoir and her Son Pierre*). It reveals a change in Renoir's life, for
his home and children were to fascinate him and he found in them
a new source of subject material (plate 71). It is a mark of his
greatness as an artist that in his many pictures of children he could
avoid the cloying sentimentality that is so often associated with the
subject. In *Maternité* Renoir expressed all the charm and innocence
he saw in motherhood. The feeling of the eternal renewal of life is
expressed in this motif, and this theme underlies much of his later
work. Renoir did many versions of this picture, including a bronze
sculpture in 1916, which perhaps more than the earlier works
conveys the primal essence of the subject (plate 72). In the late
1880s Renoir turned increasingly to subjects which express a sense
of intimacy. An example is the *Mother and Child* of about 1890

(plate 73). It is reminiscent of the formal yet intimate monumentality of a Chardin.

Renoir had been friendly with Berthe Morisot and her husband Eugène Manet since the early 1880s, and by 1885 he was a regular visitor to their weekly dinners where he met the poet Stéphane Mallarmé. When Eugène Manet died, Renoir and Mallarmé did all they could to help Berthe and her daughter Julie, and as a result Renoir became very close to both mother and daughter. He painted them several times, together and individually. The *Portrait of Mlle Julie Manet* of 1887 (plate 74) combines an almost hierarchic formality with a relaxed and graceful pose. It illustrates how by this time Renoir was developing his own conventions of drawing and representation; even in the portraits he was beginning to generalise shapes and facial types, as can be seen in this picture. A jocular comment to his son Jean reveals how he conceptualised women: 'Cats are the only women who count, the most amusing to paint. But I remember a big nanny-goat; a superb girl! I've liked doing Pekinese too. When they pout, they can be exquisite.' However, in spite of this he manages to catch the likeness of his sitter. Rather than detracting from his portraiture, the combination of the general and the particular gives his pictures a formal interest that extends beyond the identity of the sitter and creates a timeless work of art.

Plate 71
Mother and Child
1896
colour etching
$9\frac{3}{4} \times 7\frac{3}{4}$ in (24 × 20 cm)
Victoria and Albert Museum, London

Plate 72
Maternité
1916
bronze
height 22 in (56 cm)
Collection of M. Alex Maguy, Paris

Plate 73
Mother and Child
about 1890
$16\frac{1}{4} \times 12\frac{3}{4}$ in (41 × 31 cm)
National Gallery of Scotland, Edinburgh

Renoir's use of a more painterly manner at the end of the 1880s did not weaken his feeling for monumental figure composition. The forms are still closed as in the *manière aigre*, but are now defined in strong simple volumes which imply a firm basis of drawing without being constricted by it.

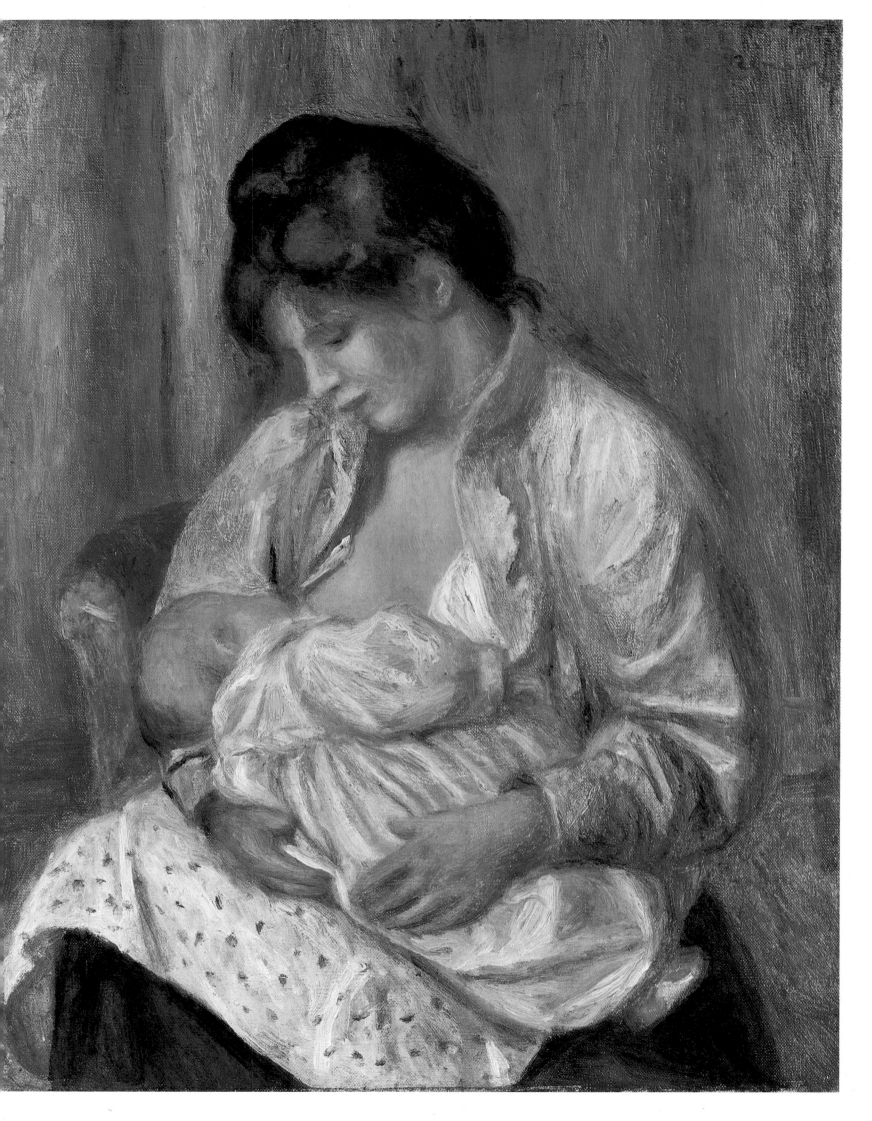

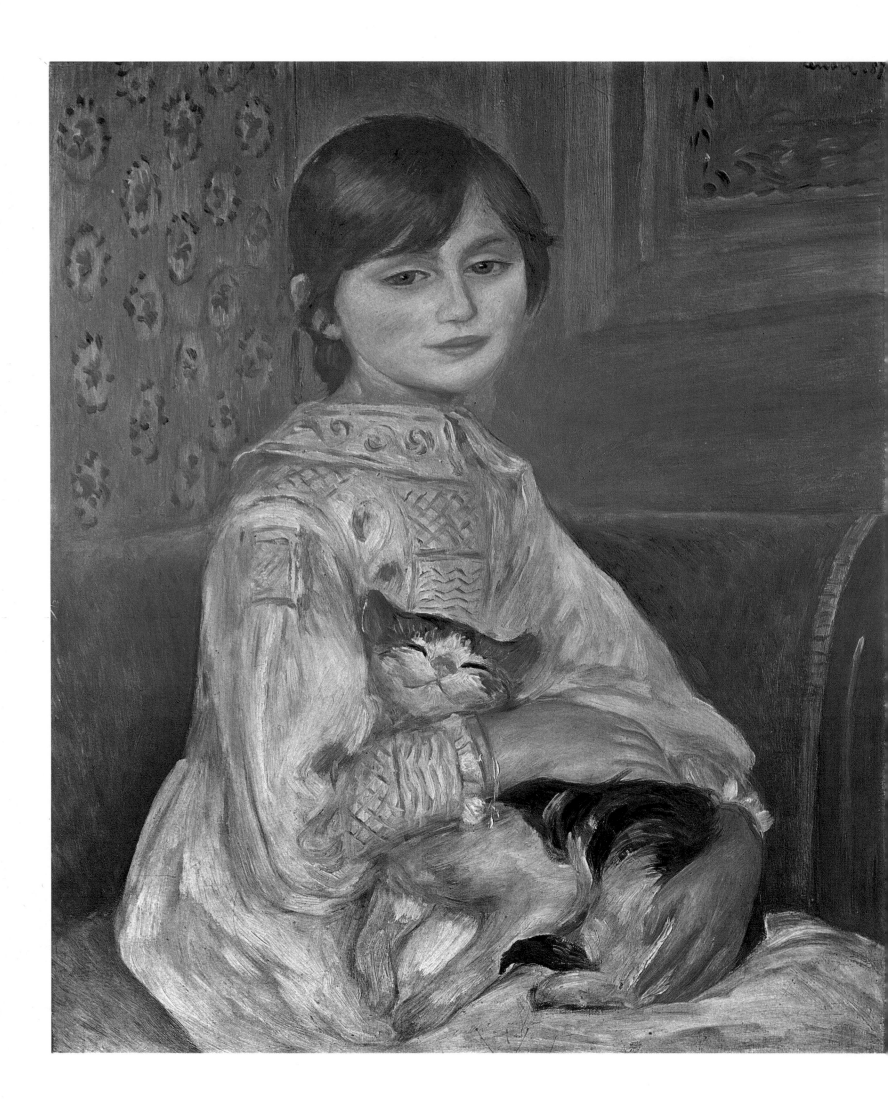

The Pearly Style and the Late Works

The year of 1888 was, in many ways, a turning point in Renoir's life. Stylistically he was beginning to free himself from the *manière aigre* which he felt to be restricting his attempts to find the monumentality and pictorial unity he sought. In the summer he worked at Argenteuil, Bougival, and Petit Genevilliers on the Seine, with his friend Caillebotte, where he painted *Young Woman Bathing* (plate 75). In this the emergence of the characteristic Renoir nude of the late period can be seen; she has broad hips, long torso, firmly rounded legs and stomach, small breasts, sloping shoulders, and a small head. The pose in this picture is a variation on the 'Venus Pudica', and by returning to Antique sources Renoir is trying to find the sensuous monumentality that had so far eluded him. Although the lighting is even and unrelated to the background, the figure is given a greater sense of plasticity and modelling by the subtle highlights on the stomach and arms and the use of longer, slightly fused brushstrokes of rich pigment. These brushstrokes are deliberately allowed to go over the firm outline of the figure to soften its form, thus enhancing its plasticity and unifying it with the background. In the summer of 1888 Renoir started to paint what may be described as his 'variation on a theme' pictures. These were a series of paintings of the same subject in which Renoir strives to develop the infinite formal possibilities inherent in the subtle variation of style and pictorial elements. One theme that preoccupied him a great deal in the early 1890s is that of girls at the piano. The germ of this idea is found in the *Daughters of Catulle Mendès* of 1888 and evolved into variations on the subject of two girls sitting at a piano, as in the *Two Girls at the Piano* painted later in 1888 (plate 1). In these theme pictures Renoir was really escaping from the problem of subject-matter, as he stated to his son Jean: 'What freedom! Not to have been preoccupied with a story, since it had been told hundreds of times. That's what is important: to escape from subject-matter, to avoid being "literary" and so choose something that everybody knows—still better, no story at all.'

Thus in Renoir's later work very little ever 'happens' except in

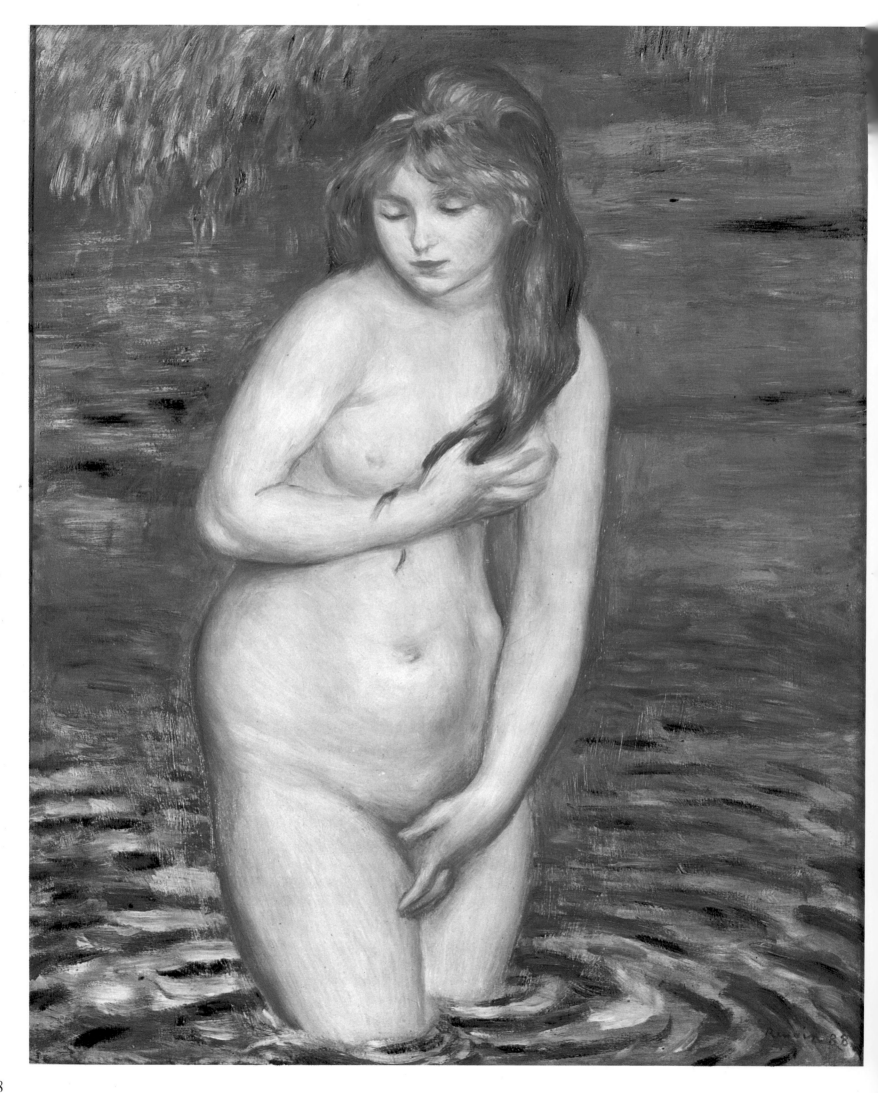

Plate 75
Young Woman Bathing
1888
$31\frac{3}{4} \times 25\frac{1}{2}$ in (80×65 cm)
Collection of Mr and Mrs David Lloyd
Kreeger, Washington D.C.

Although the figure is in the pose of the
Venus Pudica, the emphasis on soft
volumetric modelling encased within a firm
outline, the motif of hair flowing over the
shoulder, and the theme of a girl standing
in water may have been derived from
Titian, whom Renoir greatly admired.

Plate 76
Young Girls with Hats
1890
$21\frac{1}{4} \times 17\frac{3}{4}$ in (54×45 cm)
Collection of Paul Kantor, Beverly Hills,
California

The models for this picture were Berthe
Morisot's daughter, Julie Manet, and her
cousin Paulette Gobillard.

some of his pictures of Classical subjects. On a more personal level, the year 1888 showed Renoir to be extremely poor; he could not afford to contribute to the subscription that was being raised to buy Manet's *Olympia* for the State. In the autumn at Essoyes, where he was now to spend most of his summers, he succumbed to his first attack of arthritis, which was to cripple him for the last twenty years of his life.

In the difficult years from 1889 to 1893 Renoir's output of work dropped to a low ebb due to the uncertainty he was struggling to overcome in his attempts to form a new style. Thus in 1891 he wrote: 'Four days ago I was fifty and that's a bit old for a man to be seeking the light. But I have done what I could, that is all I can say.' During this period of disillusionment he spent a great deal of his time with Berthe Morisot, both at the weekly Thursday night dinners and, in the summers of 1891 and 1892, at Mézy on the

Seine, where the Manets had a country home. They frequently worked together during these visits; Renoir was charmed by the intimacy and elegance of her painting and his admiration gave her greater confidence in her own work. In 1891 they met the Polish critic and writer De Wyzewa, whose enthusiasm for their work and understanding of the increasingly formal and lyrical elements of Renoir's painting did a great deal to restore Renoir's faith in himself. During this time he started a series of paintings which developed the theme of young girls together, sharing confidences or reading. The *Young Girls with Hats* of 1890 (plate 76) and *Girls Looking at a Book* of 1891 (plate 77) have an intimacy and feeling of serenity that is also found in Berthe Morisot's work at this time. Renoir was fascinated by girls in large, soft hats relaxing in the calm of summer, and the atmosphere created in these pictures is one of complete harmony between the models and their surroundings. Their loose summer dresses and flowing hair stimulated him to loosen his brushstroke, now more expressive of surface quality and volume. The emphasis on hard outline disappeared as Renoir created unity and pictorial rhythm through the use of longer more flowing strokes which separate and fuse as the thickness of pigment varies. The brushstrokes now emerge as positive elements in creating form, the balance of colour and tone is enhanced by the plastic quality of the brushstrokes which determine and heighten the sense of modulated volume.

During the period between 1889 and 1893 Renoir began to spend his winters in the south to avoid the cold northern winters which aggravated his arthritis. In the summers he spent more time at Essoyes, gradually deserting his old summer painting grounds on the northern coast of France after 1892. It was in these years that Renoir's material fortunes changed. Durand-Ruel organised a large retrospective exhibition of his works which was a great success. He even received official recognition when, as a result of the exhibition, the government bought *The Music Lesson* for the permanent collection of the works of living painters in the Palais du Luxembourg. The money from this purchase enabled him to go to Spain with his friend Gallimard. He admired Goya and Velásquez and Titian's *Venus and the Organist* in the Prado, but deprecated the Spanish women's habit of smoking cigars. In the winter he stayed at Martigues and St Chamas in the south, from where he wrote to Berthe Morisot about the joy and stimulation he found there '. . . wondering if you wouldn't like to see the most beautiful spot in the world. This is it. You get Italy, Greece, and the Batignolles quarter of Paris all wrapped into one—plus the sea.'

The Young Girl Carrying a Basket of Fish and *The Orange Seller*

Plate 77
Girls Looking at a Book
1891
$31\frac{3}{4} \times 25\frac{1}{2}$ in (80 × 65 cm)
Virginia Museum of Fine Arts, Richmond,
Virginia

These figures combine an informality of
pose with a sense of monumentality,
characteristics that were to be typical of
many of Renoir's later nudes.

(plate 78), a pair of decorative panels executed in 1889, show how,
at last, Renoir was beginning to overcome the stylistic uncertainty
that had plagued him in the previous years. His colour range is
now dominated by the intense rich blues of the backgrounds and
the warmth of the flesh tints in the girls' faces and arms. The
interaction of these two elements, which both offset and
complement each other, intensifies the resonance of the colours.
Traces of his old style can be seen in the still firm outline of the
figures which have something of a statuesque quality. A
preparatory drawing for a work of the following year, *The Apple
Vendor* of 1890, shows in its firm and clear outlines that Renoir
still needed an underlying basis of strictly controlled monumental

Plate 78
Young Girl Carrying a Basket of Fish
and **The Orange Seller**
1889
each panel $51\frac{1}{2} \times 16\frac{1}{2}$ in (130 × 41 cm)
National Gallery of Art, Washington D.C.
(Gift of William Robertson Coe)

Plate 79
Young Girls by the Side of the Water
1893
$12\frac{1}{4} \times 16\frac{1}{4}$ in (31 × 41 cm)
Present whereabouts unknown

form to give him confidence, although the starkness of this is softened by a much freer painterly style in the finished work. This also applies to *The Young Girl Carrying a Basket of Fish* and its companion, which gain much of their surface vitality from the dynamic variation of the semi-fused brushstrokes. That Renoir still thought of the female body in terms of statuesque monumentality is indicative of his later solution to the problem of depicting the nude. He gradually moved away from the restrictions of anatomical correctness and created figures that were increasingly a product of his own vision.

The theme of girls beside the sea or a lake, seen in *The Young Girl Carrying a Basket of Fish*, was developed in the *Young Girls by the Side of the Water* of 1893 (plate 79). In this painting Renoir conjures beautiful harmonies of pink, white, green and pale blue. His unique manner of forming the rhythms of the picture space by using the relief patterns of his brushstrokes, which at once dissolve and create volume and form, can be seen in the breadth of his technique in this picture which varies from the decisive strokes on the clothes to the washes of colour which define the masses in the background. He spent the summer of 1894 at Beaulieu-sur-Mer which he had first visited in April of the previous year, and here he painted some of the most exquisite pictures in this series. Beaulieu on the coast of the Alpes-Maritimes is known as 'Little Africa' because of its warm climate, and the paintings that Renoir made there vibrate in a haze of brilliant light. These works were

Plate 80
Young Girls Picking Flowers
about 1890
65 × 81 in (165 × 205 cm)
Museum of Fine Arts, Boston

This picture is one of a pair which have as
their theme young girls picking flowers.
Both show Renoir using much thinner
pigment, only intensifying it on points of
emphasis, thus giving vitality to the picture
surface. This method of painting was
adopted in an attempt to capture the effect
of intense and all-enveloping light on
landscape and the figures in it.

anticipated as early as 1890 in *Young Girls Picking Flowers* (plate 80)
where the colours and forms are softened and partially dissolved by
the intensity of the light. The figures have now become totally
unified with their surroundings, their dresses shimmering with
reflected light.

In the works executed at Beaulieu Renoir developed the method
of laying in masses and then adding highlights to create the
volumes that was to be the basis of the work of his late maturity.
This can be seen in the figures in *A Woodland Pool with Bathers and
Washerwomen* (plate 81), an exquisitely lyrical work painted in
1901. Meier-Graefe's statement that 'The plastic fullness of his
figures alone makes it possible to use his delicate palette' is borne
out in works such as this.

Renoir's second son Jean was born in 1894, and due to

overcrowding in the old home, the family moved to the 'Château des Brouillards' in Montmartre. In the winter of 1894–95 Renoir went south again after catching flu, probably as a result of the dampness that plagued his new home. He returned to Paris in February because Jean was seriously ill, and in the following month he was greatly distressed when Berthe Morisot died. He found solace in the new friendship he had made with the picture dealer Ambroise Vollard, a new model he had discovered in Gabrielle Renard, and in his family (plate 82). Gabrielle was a cousin of Mme Renoir's from the Aube region, and she had entered the Renoir household in the previous autumn as a nurse for Jean, but it was not long before the artist co-opted her for use as one of his favourite models (plate 86).

During 1895 Renoir painted a series of pictures which illustrate his growing interest in ancient Greece. They are based on the Oedipus theme, and in two canvases entitled *King Oedipus* he illustrates episodes from the story against a background of brilliant white buildings and a shimmering blue sky. Their composition owes something to Raphael's designs for the Sistine Chapel tapestries, *The Sacrifice at Lystra* in particular. Another less literary subject in this series is *La Jocaste Tragique* (plate 83), which takes the form of a decorative panel. The expression of movement is emphasised in the long weighty curves of the body and cloak and is echoed in the broad flowing rhythms of the brushstrokes. This picture relates to the pair of *Dancers* in the National Gallery, London, of 1909. Renoir did not continue with overtly Classical themes after 1895, and he only returned to them in the years

Plate 81
A Woodland Pool with Bathers and Washerwomen
1901
18½ × 21 in (47 × 55 cm)
Metropolitan Museum of Art, New York
(Gift of Mrs Edna H. Sachs)

The theme of washerwomen by the side of a river or pond fascinated Renoir in the period at the turn of the century when he was starting to fully develop his late manner. In this picture the light plays onto the dense foliage of the trees, transforming them into swelling masses of green which glimmer in the warmth of the sun.

Plate 82
The Artist's Family
1895
67 × 54¾ in (170 × 139 cm)
Barnes Foundation, Merion, Penn.

Left to right: Pierre, Mme Renoir, Jean, Gabrielle, and the daughter of Renoir's next-door neighbour at the 'Château des Brouillards', Paul Alexis.

around 1908 with subjects like *The Judgement of Paris*. The important indication that these Oedipus sketches give is of the epic breadth that was to develop in Renoir's last manner, a style that was, in the bathers at least, stimulated by the thought of the Classical ideal. The light of the south inspired him with a view of a pantheistic world in which he could find this ideal. As Renoir said to Vollard: 'What wonderful people these Greeks! Their life was so happy that they imagined the Gods came down to earth to find Paradise and Love. Yes, earth was paradise for the Gods . . . That's what I want to paint.' Thus, although his late works are not dominated by overtly Classical subjects (his personal vision was too strong for that), it is totally permeated with the spirit of Classical art and in its details it often contains particular references to elements found in Greek art and the tradition it founded.

Between 1897 and 1900 Renoir moved towards a more complex

Plate 83
La Jocaste Tragique
1895
$12\frac{3}{4} \times 16\frac{1}{4}$ in (32×41 cm)
From the collection of the O'Hana Gallery,
London

The simple red and white colour scheme is
made fresh and vibrant by Renoir's choice
of exactly the right tones.

and harmonious style of figure painting that was to be the basis of
his late works. During this time he was further incapacitated by
arthritis. In the summer of 1897, at Essoyes, where he had just
bought a house, he fell off a bicycle and broke his arm which made
his arthritis worse and in the following year it was so bad that his
whole right side was temporarily paralysed. He spent as much
time in the south as he could in the winter and lived at Essoyes in
the summer, in an attempt to stave off the ever-increasing threat of
paralysis. In spite of all this his style became more fluid and subtle,
and the *Three Bathers with a Crab* of 1897 (plate 84) joyfully affirms
that Renoir's love of life and happiness was not soured by his own
suffering. It is a transitional work in that it is the first of the multi-
figure pictures of bathers of his late period, and as such it
retains some features of his earlier style. This can be seen in the
landscape background which relates to the style of the Beaulieu

Plate 84
Three Bathers with a Crab
1897
$21\frac{1}{2} \times 25\frac{3}{4}$ in (54×65 cm)
Cleveland Museum of Art, Cleveland, Ohio
(Purchase from the J. H. Wade Fund)

Renoir was fascinated by the problem of painting monumental figures in the process of sudden movement. This picture is a variation on *Les Grandes Baigneuses* of 1887.

pictures, and in the rather flat volumes of the figures caused by the brilliance of the light suppressing the subtleties of the skin tones that were to emerge in the later nudes.

In the bathers of the period around 1900 Renoir has managed to reconcile the needs of both light and form. In *La Boulangère* (plate 85) the figure, whilst revealing its debt to Correggio and Titian in the languorous arabesque of the pose, strictly conforms to Renoir's own canons of proportion and plasticity. By this time he had invented his own ideal of the nude by working through the Classical tradition and transcending it with his own vision. Renoir said of his figure paintings: 'As for me, I just struggle with my

figures until they are a harmonious unity with their landscape background, and I want people to feel that neither the setting nor the figure are dull and lifeless.'

In *La Boulangère* the unity and variety that he was searching for are present in the organic nature of the relationship of the figure with its background. He wanted models whose skin 'caught the light', because the effect of light on this special type of pale skin allowed him to capture the variety of tones which were the basis of the rich volumetric forms of his late nudes. Light glows on the arms, breasts, stomach and legs, creating the voluptuous plastic masses that combine the qualities of a painterly style with a sculptural conception of form.

Renoir's concern with the fine tones of skin and its delicate colouring led him to return to flower painting in his last years. In this he found a relaxation from the tension that the effort of confronting a model produced, whilst at the same time he could abandon himself to the joys of painting the radiant freshness of flesh tones. The *Gabrielle with a Rose* of 1911 (plate 86) shows how he could establish subtle nuances of handling and colour by relating the delicacy of flowers to the skin tones of his favourite model; and if a new model upset him he often used to paint the flowers in the composition and eliminate the figure! In this picture, Renoir's ability to combine extreme subtlety of colour and brushwork (see the diaphanous glaze of her chemise) with a monumental quality that has none of the stiffness of his earlier

Plate 85
La Boulangère
about 1902
21¼ × 25¾ in (54 × 65 cm)
Collection of Stavros S. Niarchos

This picture of one of Renoir's domestics is transformed by his personal vision of the Hellenistic Venus. He combines intense sensuality with a rigorous formalism.

Plate 86
Gabrielle with a Rose
1911
$21\frac{3}{4} \times 18\frac{3}{4}$ in (55×47 cm)
Louvre, Paris

Renoir: 'I look at a nude and I see myriads of tints. I must find the ones that will make the flesh come alive and quiver on my canvas.'

figure painting is evident. He achieved this through a changed relationship with his model; his youngest son Coco stated that for most of the time he could move quite freely when sitting for his father, having to be motionless for only a few minutes at a time. This was because, as Renoir said, 'she [the model] is only there to set me going, to permit me to dare things I should never have thought of inventing without her, and to put me on my feet again if I should venture too far'. The model was stimulus to his vision, indispensable as a starting and reference point from which his imagination could penetrate the abstract world of ideal form and recreate on canvas an autonomous world of his own creation. The importance of the model must not be underestimated; the work he considered to be his testament, *Les Grandes Baigneuses* of 1918 (plate 87), was stimulated by the beauty of Andrée Hessling. In *Les Grandes Baigneuses* he achieved his ideal in art, which he described as a combination of qualities that 'must be indescribable and inimitable'. The figures, calm and voluptuous, have all the

Plate 87
Les Grandes Baigneuses
1918
43¼ × 63 in (110 × 160 cm)
Louvre, Paris

The figures have been transformed into
smooth masses of amply curved flesh. In
his last years Renoir's brushwork was very
free, especially in the landscape backgrounds
where the emphasised cluster of brushstrokes
form a stimulating tactile contrast to the
smooth volumes of the figures.

timeless monumentality and fruitfulness of the landscape which
surrounds them; they are an eternal and mystic affirmation of the
power of life.

Renoir's illness – a combination of arthritis and rheumatism,
which by 1913 was to confine him to a wheelchair – necessitated
his living in the south where the warm climate did not aggravate
his condition. In the winter of 1899–1900 he stayed at Grasse and
Magagnosc in the foothills of the Alpes-Maritimes, but he did not
find a permanent home for his family until 1903 when they settled
in the Maison-de-la-Poste at Cagnes. Here Renoir found the peace
and tranquillity that he needed to continue with his work. He often
drove out into the countryside to paint the clear atmosphere and
rich, ordered landscape of the Riviera, which he captured in many
oil sketches and watercolours (plate 88). In June 1907 Renoir
bought an olive grove situated on the hills above the town, and
here he had a house and studio built (plate 89). He spent the rest of
his life at Les Collettes, as the grove was called, and he found the

Plate 88
Landscape at Cagnes
about 1903
11 × 18 in (28 × 46 cm)
Private collection, Berne

Plate 89
Renoir's small studio in the grounds of Les
Collettes, among the 100-year-old olive
trees.

garden and the view from it a constant source of inspiration. The beautiful clear shadows cast by the olive trees in his garden were the subject of several paintings, *The Garden of the Maison-de-la-Poste* being one of the finest (plate 90).

During the years at Cagnes Renoir started to paint portraits again. They were mainly of his family and friends (plate 91) as he could now afford to pick and choose as far as his commissions were concerned. Ambroise Vollard became one of Renoir's closest friends, visiting the painter as often as he could; they had a special relationship that brought the best out in both of them, and Renoir painted several portraits of the picture dealer, which are amongst his finest (plate 92). One of Renoir's favourite models at this time was Hélène Bellon, and in the *Young Girl Sitting* (plate 93) of 1909 it is evident that the ample figure of this beautiful young girl stimulated him to create one of his most monumental and, at the same time, relaxed and informal portraits. The charm of these more personal works was not lost in the more formal pieces. When Renoir visited his friends the Thurneyssens in Germany during the summer of 1910, he painted *Mother and Child (Portrait of Frau Thurneyssen and her Daughter Anna?*, plate 94) which combines the beautifully statuesque pose of the mother with the intimacy of his favourite mother-and-child theme.

In 1907 Vollard persuaded Renoir to take up sculpture, sensing

Plate 90
Garden of the Maison de la Poste, Cagnes
1906
18½ × 21¾ in (47 × 55 cm)
Collection of Stavros S. Niarchos

Plate 91
Coco, Son of the Artist
about 1906
13 × 10¼ in (33 × 26 cm)
Present whereabouts unknown

that the plastic and tactile qualities in his painting would be ideally
suited to the medium of relief sculpture. In the years around 1900
Renoir had taken to using red crayon in his sketches, finding that
the subtlety and variation inherent in the rather soft lines made by
the crayon enhanced the relief elements and the interpretation of
form. Thus he executed the relief of the *Judgement of Paris*, derived
from his picture of the same subject of 1908. He achieved an
astonishing vitality of form and plastic interest, the pattern of the
highlights being as subtle as anything seen in his painting. Renoir
was too badly crippled to undertake the manual work involved in
sculpture and he worked in co-operation with an amanuensis.
Renoir sketched a design, the general massing of which was built
up in clay by his assistant Guino. The painter had a baton attached
to his hands and by means of this would indicate whether the
assistant should add or take away clay on the model. They did not

communicate with words, but grunted to each other, indicating satisfaction or otherwise by their tone of voice. In the *Vénus Victorieuse* of 1914–16 (plate 96), Renoir's most significant sculpture, he attempted a free-standing figure of monumental proportions. It has all the grace and amplitude of gesture found in Classical sculpture. The head is small, the neck firm and erect like a column, the shoulders describe soft and even curves rendered asymmetrical by the position of the arms, and the full serene volumes on the torso balance the figure in its gentle movement expressed in the positioning of the legs.

After visiting Paris in the summer of 1919, where he saw one of his paintings hung in the Louvre, Renoir (plate 98) returned to Cagnes. In December he caught a chill whilst working in the grounds of Les Collettes; this developed into pneumonia and on Wednesday, 3rd December 1919 he died.

Renoir's Legacy

When Renoir and his friends came to the attention of the general public with their group exhibition of 1874, their work was considered either a joke or a vicious undermining of the standards of 'high art'. They were the slightly ageing *enfants terribles* of the art world and considered insane by the bourgeoisie whose values and ideals were catered for by the *pompiers* (academic painters) at the annual Salons. Although they were honoured figures by the turn of the century and their work was gradually accepted, appreciation of their painting was restricted to a relatively small number of 'advanced' connoisseurs until the last years before the outbreak of the First World War. The Impressionists were at the head of the growing and new phenomenon of the avant-garde, artists whose works and attitudes led them to become alienated from the society they lived in. They did not maintain their position at the head of the vanguard for long; their example acted as a stimulus to new art movements, and they were soon overtaken by others. By the early 1880s Seurat, Signac and the Neo-Impressionists had jumped into the breach with their more formal semi-scientific approach to art. Other movements followed in profusion: Gauguin's Synthetism, Symbolism, Art Nouveau, Cubism, Fauvism, Futurism, Vorticism, and Expressionism, and the group of painters called the Nabis, to name some of the most outstanding of many. The diversity and radical nature of these movements is indicative of the intense mental activity and confusion that reigned in the intellectual capitals of Europe, especially Paris, in the fifty years before the First World War. After the struggles of the 1880s Renoir worked in a series of styles that, although not static, were timeless. He relentlessly pursued and perfected his own vision of an ideal world, thus sidestepping the constant search for innovation and avoiding the pitfalls of modernity without conviction.

By the end of his life Renoir did not have many direct followers, Albert André his assistant and biographer being the most outstanding of the few, but at the same time his art had not dated, its visionary qualities transcending time and space. Equally, many

Plate 97
Portrait of Mlle Françoise
1915
20½ × 15¾ in (52 × 40 cm)
From the collection of the O'Hana Gallery, London

Plate 98
Renoir in old age

of his ideas were out of step with those current in the first and second decades of the 20th century. However, he stubbornly refused to see the extent of the break with the grand traditions of European culture, in which he had been at least partially instrumental, and considered himself to be the inheritor of the ideals passed down from the Greeks via Pompeii, Raphael, Poussin, Corot and Cézanne. As far as the inspiration for his personal vision went this theory was partially true; his admiration for the Old Masters persisted, and the inspiration of Greek art and Venetian painting in his late works is marked. For Renoir their example was eternally valid, but in acknowledging this he failed to see how radically the vision manifested in his own work had transformed these exemplars into something that was at once timeless and of its time. His late nudes (plate 87) were not in any way the same as Titian's, the freedom of drawing, technique, colouring and proportion marked them as a product of the early 20th century rather than of the 16th; yet at the same time the essence of the theme and expression is timeless in that it appeals to a strong urge in the viewer for an affirmation of life, abundance and order. Renoir's view of art as something that should aspire to a level of consciousness beyond the transient led him to disavow the rather precious idea of progress in art and civilisation. Occasionally he overstated his case, most notably when he said to Vollard: 'Progress in painting, no certainly, I don't admit it. There has been no progress in ideas and none in process.'

This probably represents his most fundamental, deeply felt and subjective reaction to the constant problems, common to every artist when faced with the process of painting. Nevertheless, when he wrote the preface to the French translation of Cennino Cennini's *Libro dell'arte* ('Book of Art' or 'Craftsmans Handbook'), written in the late 14th or early 15th century but published in this edition in 1911, he gave a more considered account of his attitude towards progress: 'It is necessary to take care that we do not get stuck in the form that we have inherited; it is equally necessary to make sure that, simply for the love of progress, we do not detach ourselves completely from the centuries before us. This tendency, particularly obvious among us today, is very understandable. So many marvellous discoveries have been made in the past hundred years that men seem to forget that others have lived before them.'

Thus, although he never saw his art as revolutionary and refused to acknowledge the importance of the fundamental changes that had taken place in painting during the previous thirty years, he did not shut himself off from the next generation of artists, and his example and works influenced them both directly

and indirectly. Furthermore, in the troubled middle period of his life, the direction of his work was similar to that of his younger contemporaries, although its manifestation was strikingly different. The classicising tendencies shared by the Neo-Impressionists and some of the Impressionists in the mid 1880s have already been touched upon, and of all the similarities to be found between the two generations at this time, those between Renoir and Seurat are perhaps the most consistant. Although Renoir never embraced Neo-Impressionist theory or practice as did Pissarro for a short time, his general aims and the conclusions he drew about the nature of Impressionism are strikingly similar to those held by Seurat. They both held the Classical tradition of French painting in high regard and considered themselves to be heirs to it; consequently they thought that Impressionism was too imprecise, lacking the structure and qualities of line found in the works of Poussin and Ingres. Although they reached this conclusion simultaneously at the end of the 1870s, they had arrived at it from different directions. Seurat had a more analytical approach based on a formal education and a wide knowledge of colour theory, whereas Renoir moved towards Classicism because of his dissatisfaction with his

Plate 99
Georges Seurat
La Parade
1887–88
$39\frac{1}{4} \times 59$ in (99 × 149 cm)
Metropolitan Museum of Art, New York
(Bequest of Stephen C. Clark, 1960)

In comparison with this picture, Renoir's *Les Grandes Baigneuses* is very close to the surface manifestations of Classicism. Nevertheless, Seurat's insistence on rigid horizontal and vertical compositional elements, the stillness of his figures, and compression of his pictorial space is more strictly Classical than is the *Grandes Baigneuses*, which has been tempered by Renoir's admiration for French 18th-century figure painting.

already highly developed style. Thus it was in their admiration of the French Classical tradition and their appreciation of the Old Masters (they admired Veronese and Delacroix as much as Poussin and Ingres) that they found the most common ground. They also believed that the only way to revive Classical values was to revitalise them with all that they had learned from their different appreciations of Impressionism, although in Renoir's case this attitude does not appear to have been a conscious one. Renoir and Seurat were not friends but were aware of each other's work as they had some mutual acquaintances. Their similarity of outlook did not result in their work looking very much alike; their painting techniques differed and Renoir developed the possibilities of pure outline conveying both form and movement to a far greater extent than did Seurat. This becomes apparent when Renoir's *Les Grandes Baigneuses* of 1887 (plate 87) is compared with Seurat's *La Parade* of 1887–88 (plate 99). Nevertheless it is surely more than a coincidence that Renoir's most purely Classical phase coincided with the brief flowering of Seurat's art (although by the time Seurat died in 1891 Renoir had moved away from the rigid superimposition of Classicism on his more natural and spontaneous painterly style).

One of the artists most directly influenced by the example of Renoir's work was Vincent van Gogh. He had been aware of Renoir's work since May 1885, when he wrote to his brother Theo about the death of an artist whom he admired: 'Lançon is dead as I heard. I have followed his work for years and never has anything bored me. There is life in every pencil stroke. If such a one dies, of that same race as the Regameys' and Renoir, it is a loss and leaves an empty place.'

This brief obituary illustrates van Gogh's rather undiscerning attitude when it came to appreciating the work of other artists. Renoir is placed with two comparatively mediocre figures, but it is significant that he sees exactly what the older artist was aiming at in the mid 1880s, a pure and vivacious use of line. This perceptive admiration does not appear to have borne fruit immediately, and it was not until van Gogh stayed in Paris between March 1886 and February 1888 that any direct influence can be traced. Towards the end of this period (early in September 1887) he painted a *Landscape near Paris* which, in its brushwork, appears to owe a great deal to the style Renoir was using in the late 1870s and early 1880s. In this he used a similar massing of slightly dry brushstrokes which, like Renoir's, dictate the rhythm and unity of the picture space. However, van Gogh differs in his more even and heavy application of pigment.

When van Gogh was living at Arles from February 1888 to May 1889, he made several references to Renoir's work in his letters to Theo. It is not only Renoir's technique that impressed him, but also its rightness for revealing the light conditions, and their effect on objects, which prevail in the south. Thus in a letter to Theo of 4th May 1889 he stated: 'I think very often of Renoir and that pure clear line of his. That's just how things and people look in this clean air.' This shows that he was now thinking of Renoir's *manière aigre* rather than the earlier painterly style. Accordingly, in works like *Boats at Les Saintes-Maries* of June 1888 and *La Berceuse* of January–March 1889, van Gogh develops the use of a strong and vigorous outline. This did not apply to all his works as he was not painting in a single-minded pursuit of one manner, but rather

Plate 100
Vincent van Gogh
Rose Bushes in Flower
1888
13 × 16½ in (33 × 41 cm)
F. 510
National Museum of Art, Tokyo

experimenting with several ideas which contributed to his own emerging style. Thus only a little later he vividly recalled his experience of Renoir's more painterly style in a letter to Theo of 13th May 1889: 'You remember we saw a magnificent garden of roses by Renoir. I was expecting to find subjects like that here, and indeed, it was that way while the orchards were in bloom. Now the appearance of things has changed and become much harder.'

This reveals that for at least part of the time he was thinking of the south in terms of Renoir's painting, in spite of the teaching to the contrary he had doubtless received from Gauguin, who had stayed with him for a time before he cut off part of his ear. It also helps to partially explain why he was attracted to both aspects of Renoir's style – the painterly and the hard-edged. He refers to Renoir's flower painting which Renoir considered to be his most relaxed form of work, giving him adequate scope to use rich colour and magnificent swirls of pigment. Van Gogh found this an inspiration when he contemplated luscious blooms and foliage, and thus in works like *Rose Bushes in Flower* of 1888 (plate 100) he used a Renoir-influenced technique to capture the richness and opulence of his subjects, although by this time the power of his vision and his use of brushstrokes was far more individual than they had been in the *Landscape near Paris*. When the intense sunlight of midday in summer sharpened outlines and bleached colours it may well have brought to mind Renoir's works of the *manière aigre*, with their exquisitely light and sensuous outlines.

Where Renoir's work, inspired by the light of the south, and for that matter Monet's as well, did not satisfy van Gogh, was in the interpretation of feeling. In a letter of May 1890 to the critic Isaäcson, he stated that nobody had yet managed to 'explain somebody like Puvis de Chavannes who would eventually manage it. Monet and Renoir might have shown the light of the south, but they had not used colour as he now did to suggest 'some emotion of an ardent temperament'. They had been too concerned with what the critic De Wyzewa called 'the realistic representation of sensation'. What van Gogh found for himself in the south, with reference to the work of Renoir and Monet, was that a rich and direct technique could be used to express with great immediacy the artist's emotion. But in this context it is interesting to note that the work of Monet and Renoir was being seen in exactly these terms as early as the mid 1880s. De Wyzewa, in an article for the Symbolist-orientated magazine, *La Revue Wagnérienne* of May 1886, entitled '*L'art Wagnérien: la peinture*', stated with reference to their work: 'These colours and contours, and these phrases, from having been mere illustrations of visual experience, now became

bound to inner emotions . . . some painters . . . used colour and line in order to achieve a symphonic composition, ignoring the visual subject to be represented.'

This view of Renoir's work in particular was not a popular one, but it was increasingly to be accepted as the basis for appreciation by the critics and connoisseurs who admired the paintings executed from the 1880s onwards. Perhaps it would not be too wild to surmise that van Gogh sensed these elements in Renoir's painting without being conscious of them and found them to be of use in the formation of his own more expressionistic style.

Renoir's association with the Parnassian poets and their friends led him to become involved with the group of artists, poets and writers contributing to the Natanson brothers *La Revue Blanche*, one of the most sophisticated and advanced of the small avant-garde magazines which sprang up in profusion at the end of the 19th century in Paris. From the early 1870s Renoir's painting, along with Monet's, had shared certain ideals with the Parnassians. In 1872–73 Renoir was trying to make his painting as impersonal as possible; this attitude was advocated by the Parnassians, as was the wish for conciseness and clarity in art. When Renoir started contributing work to Charpentier's magazine, *La Vie Moderne*, he was probably closest to this group. He knew the poet who was in many ways their co-ordinator, de Banville, and had met, at the various cafés he frequented, others including Catulle Mendès, Villiers de l'Isle Adam, Rimbaud (who was not strictly a member of the group) and Verlaine, whose work, especially an early volume of poems entitled *Fêtes Galantes* of 1869, with its evocation of delicate 18th-century inspired scenes, has often been associated with Renoir's work of the 1870s. Perhaps the most fulfilling of Renoir's relationships with poets was that with Mallarmé, who became one of his closest friends. They first met through a mutual acquaintance with Manet in the late 1870s, but became increasingly friendly throughout the 1880s, meeting at least once a week at Berthe Morisot's small dinner parties. Renoir also occasionally went to Mallarmé's famous Tuesday afternoon meetings where Verlaine, Villiers de l'Isle Adam, de Banville, Manet, Mendès, Redon, Natanson, Monet, Rodin and Whistler congregated, although not all at once, to partake of meagre fare and rich conversation. The portrait Renoir painted of Mallarmé was one of the poet's most treasured possessions, and their mutual admiration for each other's art was manifested in 1891 when Renoir illustrated the frontispiece to Mallarmé's volume of poems entitled *Pages*. This showed one of the beautiful, rhythmically balanced nudes that were to become increasingly important in

Plate 101
Aristide Maillol
Portrait of Renoir
1907
bronze
Niedersächsisches Landesmuseum, Hanover

Renoir's art after the turn of the century. Renoir freely admitted that he did not understand all Mallarmé's writings and at first their friendship appears rather unlikely, but Renoir admired his friend's originality and the 'delicious simplicity' of his language. That such a relationship between the poet, of whom Rodin said, 'How much time will nature need to create such a brain again?' and Renoir grew and lasted until Mallarmé died in September 1898 reveals that at least some of the myth of Renoir being a noble savage amongst such refined figures is untrue. Renoir's love of simplicity and aversion to empty theorising must not be confused with a lumpish simple-mindedness.

It was through Mallarmé that Renoir became friendly with the artists involved with *La Revue Blanche*, primarily Vuillard and Bonnard. On having seen Bonnard's illustrations for *Marie*, a book published by *La Revue Blanche*, he had written to the younger artist praising his work ('You have a touch of enchantment . . . It's a precious gift'), showing that his concern for quality in art, even in those younger than himself and whose painting style was different from his own, was constant. Bonnard's feeling for the charm of people enjoying themselves, as in *Au Palais de Glace* of 1898, must have reminded Renoir of his own earlier works like *La Moulin de la Galette* (plate 54). Renoir later became friendly with some of the Nabis group of painters, of whom Bonnard and Vuillard were two leading members. Jean Renoir dates this relationship from 1905, although Renoir had met Bonnard as early as 1898 at Mallarmé's funeral. The association with the group did not give rise to any direct stylistic interaction, but it did stimulate thought on certain theories of art in one of the most articulate and individualistic of their number. Maurice Denis had visited Renoir in 1906 and remained an admirer of his work throughout his life. After Renoir died, he wrote an article on the oration given at the funeral by the curé of Cagnes. This appeared in *La Vie* of 1st February 1920, and in it he associates Renoir's art with religious painting, an attitude that would have surprised Renoir himself, but which was to be important for Denis' own theory of church decoration. He stated: 'Those who believe in the resurrection of the flesh, that too little known dogma, will be especially pleased to read the eulogy of a painter of the flesh by a priest delivered during a Catholic ceremony . . . Pagan or not, the figures of Rubens or Renoir have been sanctified by painting.'

Thus art and its greatest exponents transcended and united the paradoxical elements of sensual pleasure and eternity. The physical had transcended its nature by living for ever in great art. Renoir, for Denis, was one of the few great artists to have

managed this, and in his *Nouvelles Théories* he summed up what Renoir had taught: '. . . the luxury, the richness of the craft! And above all the voluptuousness. That is what Renoir teaches.' Renoir's whole body of work stands as eternal testimony to this.

Aristide Maillol's sculptures, perhaps more than the work of any other artist, most closely resemble Renoir's late works, the nudes in particular. It was Maillol's example that inspired Renoir to take up sculpture. Vollard had commissioned him to make a bust of Renoir in 1907 (plate 101), and while modelling for this, Renoir became fascinated by the manner in which the sculptor could, by every movement of his fingers, bring the clay model to life. The example of the *Portrait of Renoir* acted as the direct inspiration for Renoir's earliest essay in sculpture, the portrait medallion of Coco which has a similarly lively visual interest. The two men did not know each other for very long, and Maillol, 47-years-old when he first met Renoir, was a mature artist in his own right, but they did have an astonishingly similar outlook. They admired each other's work and shared a similar point of view on their links with the grand tradition of European culture, although Maillol looked further afield for his inspiration. Thus, although they both admired Titian, Veronese, Jean Goujon, Greek sculpture, and the world evoked by the Greek pastoral poet Theocritus, Maillol also looked to Indian and Egyptian sculpture for inspiration. They both found that the female nude fulfilled their artistic ideal and treated it in a similar manner; Waldemar George's comment that 'Maillol, well-versed in the science of structural form, sacrificed anatomy to rhythm' could apply equally to Renoir's late paintings and sculptures of the nude. *Pomona* of 1902–05 (plate 102) shows that Maillol's free-standing sculpture had many features in common with Renoir's work, including their mutual preference for broad-featured, heavy-limbed models. But this work also reveals the equally important differences, and a comparison between this and Renoir's *Vénus Victorieuse* of 1914–16 (plate 97) shows that, although they are both concerned with the rhythm and volume of the limbs, Maillol moulds them within a firmer outline and his figures are more tightly contained than Renoir's. Maillol differentiates more sharply between the elements of the body, although still uniting them in an overall rhythm, and it is to control this that he resorts to tauter outlines for the figure as a whole. Renoir's figure is more mobile and flowing, there is a sense of growth overcoming the heaviness of the limbs which is not present in the Maillol. Thus, although Renoir was prepared to learn until the end of his life, he only used what he felt would further realise his unique and timeless vision.

Plate 102
Aristide Maillol
Pomona
1902–05
bronze
Jardin des Tuileries, Paris

125

Bibliography

Barnes, A. C. & De Mazia, V., *The Art of Renoir*, Minton, Balch & Company, New York, 1935

Champa, K. S., *Studies in Early Impressionism*, Yale University Press, New Haven, Connecticut, 1973

Daulte, F., *Renoir*, Thames & Hudson, London, 1973

Meier-Graefe, J., *Auguste Renoir*, translated from German to French by A. S. Maillet, H. Floury, Paris, 1912

Hanson, L., *Renoir, The Man, the Painter, and His World*, Leslie Frewin, London, 1972

Perruchot, H., *La Vie de Renoir*, Hachette, Paris, 1964

Renoir, J., *Renoir, My Father*, William Collins Sons & Company Limited, London, 1962

Rewald, J., *The History of Impressionism*, 4th edition, Secker & Warburg Limited, London, 1973

Rivière, G., *Renoir et Ses Amis*, Paris, 1921

Rouart, D., *Renoir: A Biographical and Critical Study*, translated by J. Emmons, Skira, Geneva, 1954

Venturi, L., *Archives de l'Impressionnisme*, Durand-Ruel Editions, Paris & New York, 1939

Vollard, A., *La Vie et l'Oeuvre de Pierre-Auguste Renoir*, A. Vollard, Paris, 1919

Acknowledgments

Plate 62 is reproduced by permission of the Trustees of the National Gallery, London; plates 26 and 66 by courtesy of the Art Institute of Chicago; plate 48 by courtesy of John Mitchell & Son, London; plate 3 by courtesy of John Rewald.

Acquavella Galleries, Inc., New York 60; Albright-Knox Art Gallery, Buffalo, New York 94; Archives Photographiques, Paris 102; Art Institute of Chicago 26, 66; Photo copyright 1975 The Barnes Foundation, Merion, Pennsylvania 12, 34, 36, 82; Bulloz, Paris 95; Christie's, London 83; Sterling and Francine Clark Art Institute, Williamstown, Massachusetts 39, 51, 57, 65; Cleveland Museum of Art 4, 84; A. C. Cooper Ltd., London 63, 90; Courtauld Institute Galleries, London 45, 92; Durand-Ruel & Cie, Paris 61; Richard L. Feigen & Co., Inc., New York 64; Fogg Art Museum, Harvard University, Cambridge, Massachusetts 33, 50; Galerie de l'Élysée, Paris 72; Galerie Nathan, Zurich 43; Hamlyn Group: Alpha Fotostudio, Essen 13; D. J. Clergue, Cagnes-sur-Mer 96; Gerhard Howald, Berne 88; Studio Lourmel 77, Paris 38; Walter Steinkopf, Berlin 15; John Webb 16; Hamlyn Group Picture Library 53, 54, 59, 71, 74; André Held/Joseph P. Ziolo, Paris 85; Robert von Hirsch, Basel 25; Joslyn Art Museum, Omaha, Nebraska 1; Mr and Mrs David Lloyd Kreeger, Washington, D.C. 75; Kröller-Müller Stichting, Otterlo 20; Kunsthalle, Hamburg 40; Metropolitan Museum of Art, New York 21, 28, 56, 81, 99; John Mitchell & Son, London 48; Musées Nationaux, Paris 2, 19, 23, 42, 52, 70, 86, 87, 93; Museu de Arte de São Paulo, Brazil 8, 11; Museum of Fine Arts, Boston, Massachusetts 80; Nationalgalerie, Berlin 67; National Gallery, London 62; National Gallery of Art, Washington, D.C. 6, 10, 30, 37, 46, 47, 55, 78; Nationalmuseum, Stockholm 9, 27; National Museum of Western Art, Tokyo 31, 100; The Norton Simon Foundation, Los Angeles, California 24; Niedersächische Landesgalerie, Hanover 101; O'Hana Gallery, London 97; Philadelphia Museum of Art 68; Photographie Giraudon, Paris 22, 32, 69; Portland Art Museum, Portland, Oregon 44; Radio Times Hulton Picture Library, London 89, 98; Oskar Reinhart Collection 'Am Römerholz', Winterthur 5, 29; John Rewald 3; Sam Salz Inc., New York 7; Tom Scott, Edinburgh 73; Sotheby & Co., London 17, 18, 58, 76, 79, 91; © SPADEM 26, 28, 96, 101, 102; Staatsgalerie, Stuttgart 49; Virginia Museum, Richmond, Virginia 77; Wadsworth Atheneum, Hartford, Connecticut 41; Wallraf-Richartz-Museum, Cologne 14; Wildenstein & Co. Inc., New York 35.

Index